FIRE ON THE MOUNTAIN

The Nature of Volcanoes

Fire on the Mountain

The Nature of Volcanoes

Photographs by
DORIAN WEISEL

Text by
CARL JOHNSON

CHRONICLE BOOKS
SAN FRANCISCO

Printed in Hong Kong.

Book and cover design by Visual Strategies,
San Francisco.

Library of Congress Cataloging-in-Publication Data

Weisel, Dorian.
 Fire on the Mountain: the nature of volcanoes /
photographs by Dorian Weisel; text by Carl Johnson.
 p. cm.
 ISBN 0-8118-0671-5
 ISBN 0-8118-0493-3 (pbk.)
 1. Volcanoes. I. Weisel, Dorian. II. Title.
QE522.J59 1994 93-29204
551.2'1—dc20 CIP

Distributed in Canada by Raincoast Books,
112 East Third Avenue, Vancouver, B.C., V5T 1C8

10 9 8 7 6 5 4 3 2 1

Chronicle Books
275 Fifth Street
San Francisco, CA 94103

For my heroes, Sam and Max

with a special thanks to
Maurice and Katia Krafft

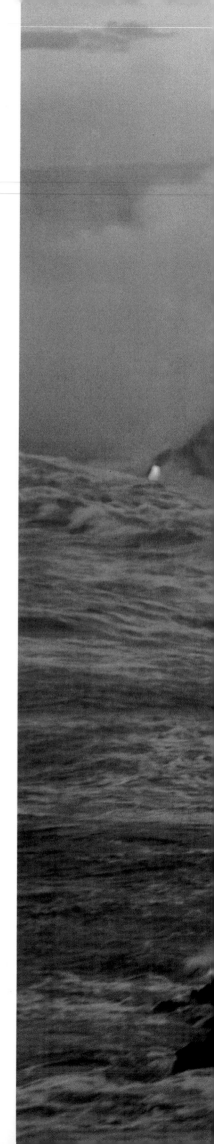

Foreword

I have grown to know the Earth as volcanic. Born in California, I explored during my youth the natural wonders of the great Northwest, feasting on the seasons: a spring day when the fog rolls back to reveal a rugged coast lined with redwoods; summer in the mountains, the sky—from horizon to horizon—so incredibly blue; the landscape in fall, majestic mountains jutting through a patchwork of greens interwoven with yellows, reds, and browns; and winter under a blanket of snow. But nothing that reached out to me and said "Volcano!"

I moved to Hawaii, called the "Big Island," a tiny gem right in the middle of the largest ocean in the world. The barren lava flows greeted my concept of swaying palms and white sand beaches with the realization that this place was different. Not a mountain on the horizon that you can count upon to grace your landscape forever, but a living, breathing, erupting volcano! This place is alive with change. Here the land moves. Here the process that shapes the Earth shapes our days. Here there is literally *Fire on the Mountain.*

Dorian Weisel, Volcano, Hawaii

Acknowledgments

We would like to acknowledge all of the people who have given so much of their time and resources, so much of themselves, to make this book the gem that it is. Thank you, Marian Berger, Martin Bishop, Steve Brantley, David Clague, Phil and Arden Coturri, Robert Decker, John Dvorak, Jerome Garcia, Kim Grosso, Joe Halbig, Christina Heliker, Ken Hon, Nancy Johnson, Jim Kauahikaua, Harry Kim, Bob Koyanagi, Bill Lacy III, Stephen Lang, J. R. Lewis, Jack Lockwood, Margaret Mangan, Tari Mattox, Dennis McNally, Asta Miklius, Tina Neal, Reggie Okamura, David Okita, Daisuke Shimozuru, Charlotte Stone, Jane Takahashi, George Ulrich, Tom Wright, and the staff of the Hawaiian Volcano Observatory and Hawaii Volcanoes National Park.

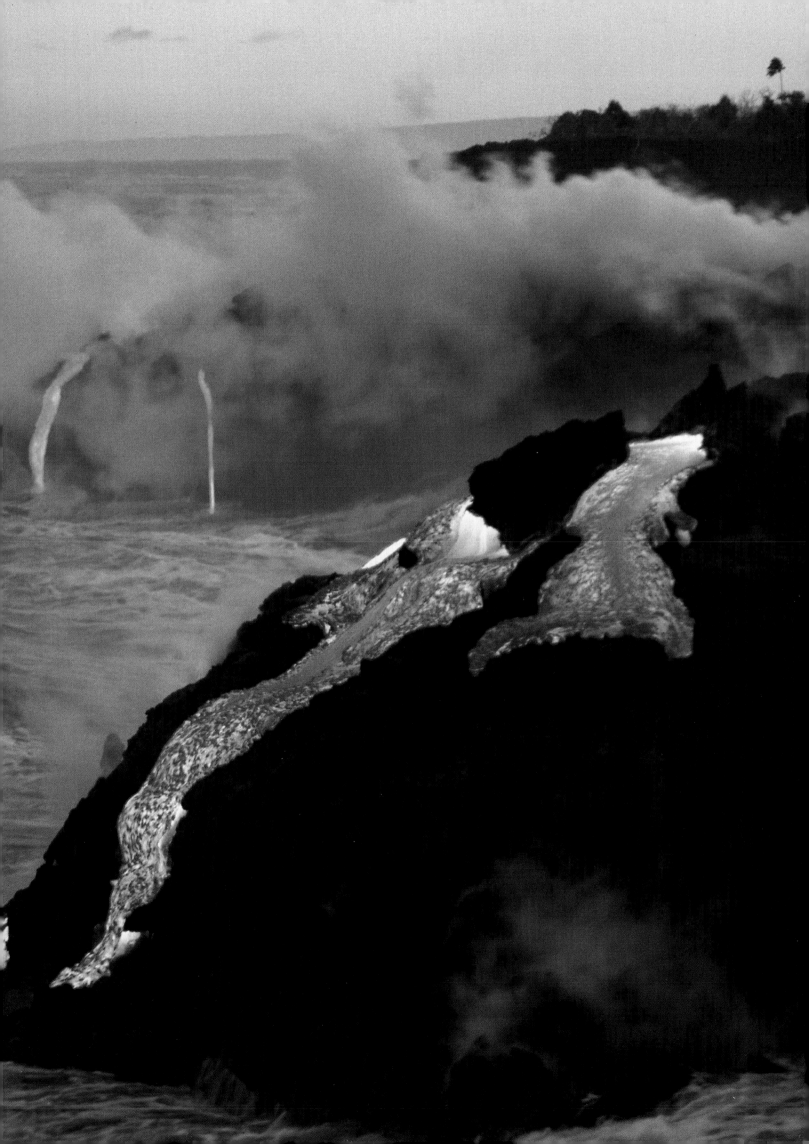

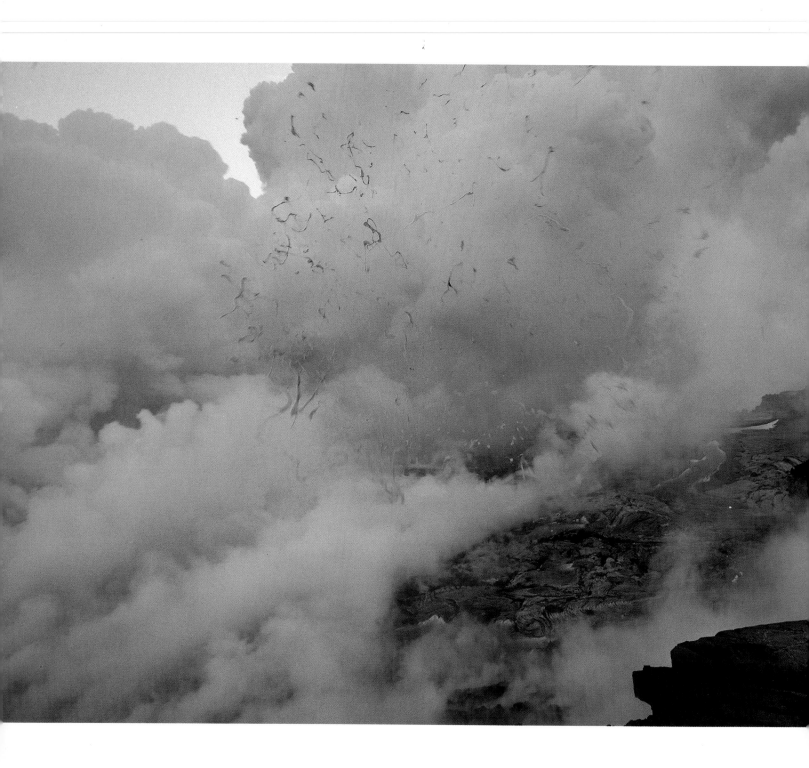

Contents

Introduction

L ike moths to a flame, some of us are drawn to volcanoes from every corner of the world to gaze in wonder as jets of molten rock are thrown skyward during eruptions. Volcanoes are windows into the heart of planet Earth, tiny peepholes into cosmic processes that began billions of years ago, when the galaxy and all the stars exploded from a point in space no larger than the period at the end of this sentence. Volcanoes are the source of all things we know—the land, the oceans, the atmosphere, and possibly even the beginnings of life. Understanding volcanoes gives us a clearer perspective of our place in the universe.

When we view Earth, we see a planetary body slowly cooling as its internal heat is conducted to the surface and radiated into space. Even though Earth has some internal heat sources, it still gets a bit cooler with each passing century. As it cools, the level of volcanic activity steadily declines. Eventually, Earth will be as cold and still as the moon, which cooled more quickly because of its smaller size. To understand volcanoes we must determine where the Earth is in this cooling process. We need to understand the birth and evolution of our planet.

Each volcano has its own story to tell, and in many respects each is much like every other. Every volcano has a beginning, then erupts again and again for a few tens of thousands of years as it grows, only to be worn down by ice, wind, and rain as another rises to take its place. In order to understand volcanoes, we must first learn how they grow. We can imagine the deep, hidden chambers that lie beneath the surface and explore the creative processes that give birth to the land. We can trace floods of incandescent, molten rock as they add layer upon layer to the Earth's surface, and observe dramatic explosions of steam as rivers of lava pour into the sea.

As the population of Earth increases, more of the land around volcanoes is used. Farmers till the rich volcanic soil. Cities and towns spring up, and roadways are built across recent lava flows. True, there are sometimes unfortunate consequences to such actions, and throughout time, many have paid the ultimate price. However, there is far more to the story than this. Volcanoes are a part of the Earth's workings that virtually lay the foundation for all life. Perhaps we are more aware of their destructive aspects because they come so swiftly. But the slower, more subtle processes—the building of the land, the nourishing of the soil, and the filling of the oceans—constitute the long-term impact that volcanoes have on our lives.

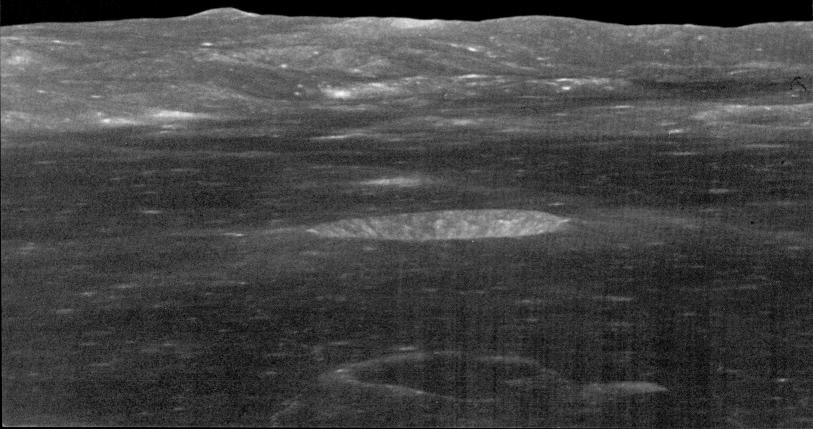

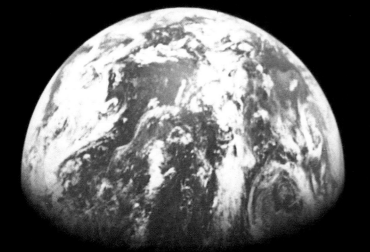

Chapter 1

Birth of a Planet

Chapter 1

Birth of a Planet

L ong before there was a sun, moon, or Earth, this part of the universe was occupied by a gigantic, expanding cloud of extremely hot gas. Such clouds, called nebulae, are formed when older stars explode violently, spreading the stuff of which they are made across the heavens. New stars are born within such clouds as birth follows death in a seemingly endless cycle of creation. Everything we see around us—the rocks, the trees, the air—came from these beginnings. Indeed, each of us is made of the remains of ancient, exploding stars.

As the nebula began to collapse and cool, it flattened into a slowly spinning disk. The sun and the planets were created early in this process. The first solids to form were globules of materials with the highest melting temperatures. Hailstones form in a similar manner as layer upon layer of ice freezes onto their surfaces until they become so heavy that they fall from the clouds. Some of the earliest fragments are still preserved in the interiors of meteorites. As the fragments began to coalesce, the largest bodies formed the planets. Gases released from the interior gave each planet its first atmosphere. The early solar system was a violent place, and meteors constantly battered the surface of the forming planets. Heat generated by impact covered each planet with a sea of molten rock. This process continues today as shooting stars streak across the night sky, though their numbers are now greatly diminished, only rarely reaching Earth's surface.

Most of the material in the solar nebula was concentrated at the center of the rotating nebular disk in a giant ball destined to become the sun. At first it was dark, and cloaked in a thick layer of gas and dust. As it grew, pressure and temperature increased. Eventually, the atoms and elements of the sun's interior were pushed so closely together that nuclear reactions could occur as hydrogen transmuted to helium. This same process occurs briefly during the explosion of a hydrogen bomb, but for the sun and other stars

it continues for billions of years. The violent blast from the sun's ignition swept much of the remaining nebular material out of the solar system, and light flooded the heavens. At the same time, the inner planets—Mercury, Venus, Earth, and Mars—were stripped of the atmospheres that had developed during their early formation. The present atmospheres of these planets resulted from the gases trapped within, vented to the surface during volcanic activity.

As planetary bombardment declined, Earth's surface remained covered by a pulsating ocean of molten rock. Violent internal currents stirred in its depths. Many millions of years passed before a thin skin of solid rock began to form. As Earth slowly cooled, liquids began to separate, much like oil and water after being shaken in a jar. Liquid iron and other metals, mixing poorly with molten rock and being much heavier, sank to form the Earth's core. At the center of Earth is the inner core, compressed by incredible pressures to a solid iron ball some 2,400 kilometers across, and suspended in a sea of liquid iron. The lighter, rocky material formed the thick layer above the core called the mantle. The lightest material rose to the surface forming the major continents where today the oldest surface rocks are found.

As the heat of planetary formation was radiated back into space, the thin, rocky skin thickened into plates of rock many kilometers thick. The largest of these plates crashed and ground against each other, raising the mountains and sculpting the continents. Several times the Atlantic Ocean opened, only to close again, each time creating lofty mountain ranges. The Appalachian Mountains are the eroded remains of the last time this happened 200 million years ago. Earthquake faults hundreds of kilometers long, like the San Andreas Fault in California, mark the place where giant plates rub against each other. On the floor of the world's oceans, a range of mountains 60,000 kilometers long was formed as massive plates were pulled apart and the gap between them was filled with molten rock welling up from below. Paralleling some coastlines are lines of volcanoes, where one plate is forced beneath another. A new volcano is born whenever melted rock from below finds its way to the surface through cracks and passages in the plates. The modern theory that describes and explains these processes is called plate tectonics.

Thus a planet cools, and volcanoes are an important part of this process. Although their numbers have diminished, they still play the same critical role in making the planet Earth a gem among the stars. Gases from volcanoes formed the atmosphere, rich in carbon dioxide, later broken down into oxygen by growing plants. Steam from erupting volcanoes formed the clouds that made the rain and filled the oceans of the world. From volcanoes came much of the land we walk on, rich soil weathered from volcanic rocks. Volcanoes and products of volcanoes are the very foundation of life on planet Earth.

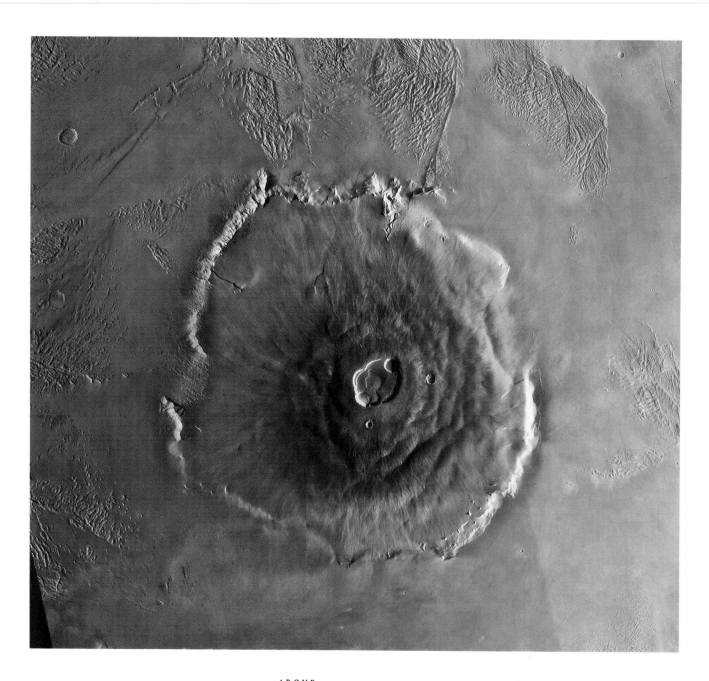

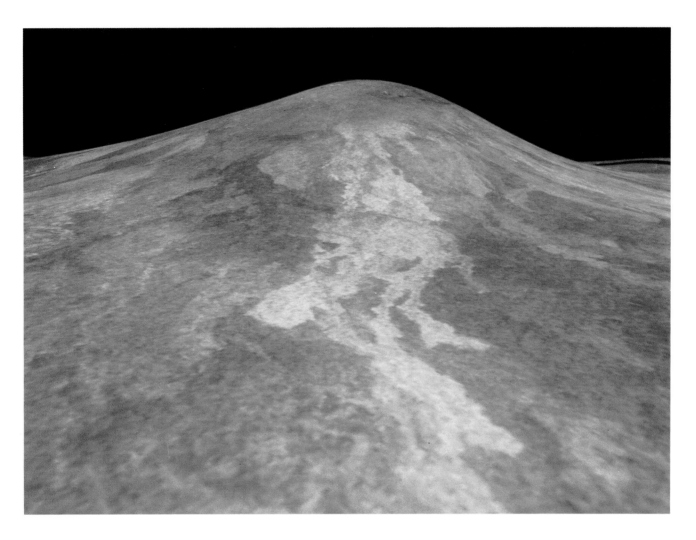

ABOVE

Sif Monte is typical of the many shield volcanoes
strewn over the surface of Venus.
Although conditions of temperature and pressure are far
different there than they are on Earth, shields are a
significant form of volcanism on both planets.
The level of volcanic activity is high enough that
relatively few impact craters are found on its surface.

COURTESY JPL.

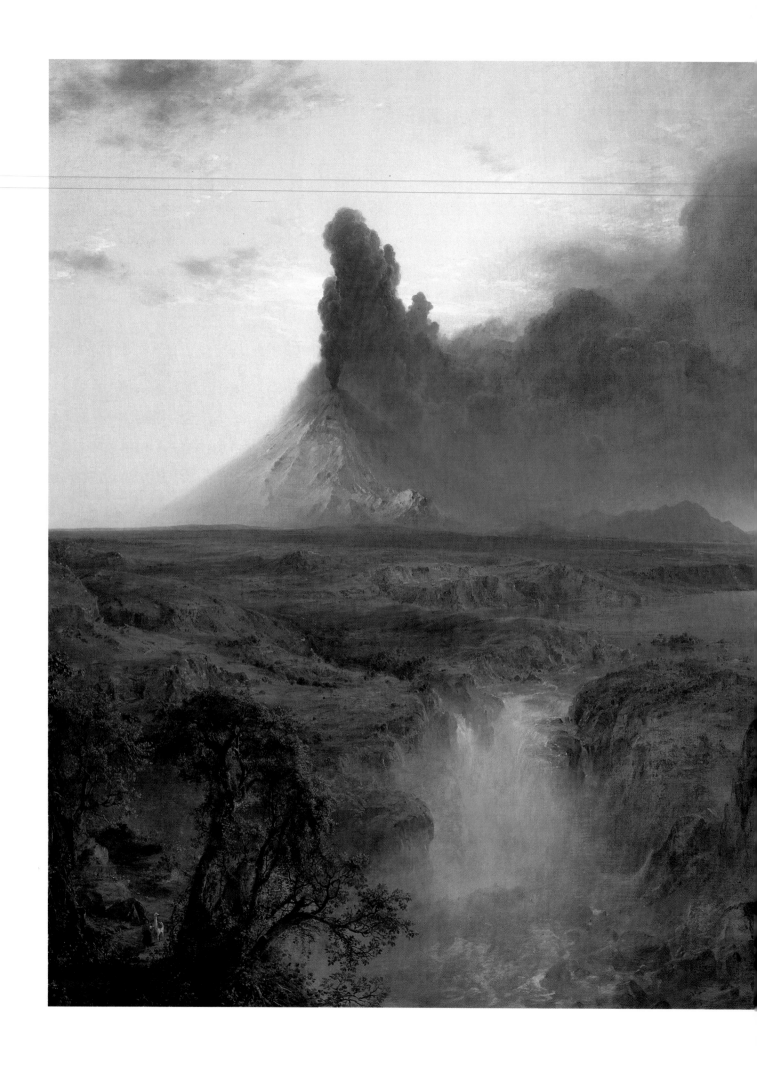

LEFT
Earth's atmosphere evolved from gases vented through volcanoes when the planet was still young. Volcanoes still play a major role, significantly reducing surface temperatures and changing worldwide weather patterns for years following each major eruption. 1862 PAINTING OF COTOPAXI VOLCANO BY FREDRIC ERWIN CHURCH, COURTESY DETROIT INSTITUTE OF ARTS.

RIGHT

As Earth cooled, molten iron and rock with different densities segregated to form a layered structure. Molten iron and nickel descended to form the core, and rocky material became Earth's mantle, or thin, outermost crust. The continuation of these cooling processes is responsible for virtually all volcanic activity on Earth's surface. The heart of the Earth is a metallic sphere, somewhat smaller than the moon, made solid by tremendous pressures.

PAINTING BY MARIAN BERGER.

BELOW

The eruption of Pinatubo Volcano in the Philippines on June 15, 1991, spread a high altitude blanket of dust and volcanic gases over the entire planet, changing weather patterns and causing spectacular sunsets. These effects could easily be seen from the summit of Mauna Kea Volcano on Hawaii where, at an elevation of 4,000 meters, Earth's upper atmosphere can be observed more directly. The sunset seen behind the 2,500-meter peak Hualalai Volcano, also on Hawaii, is tinged with pastel colors from volcanic gases and ash that have circled Earth many times. Such large volcanic eruptions can alter weather patterns worldwide, touching all of our lives in the process.

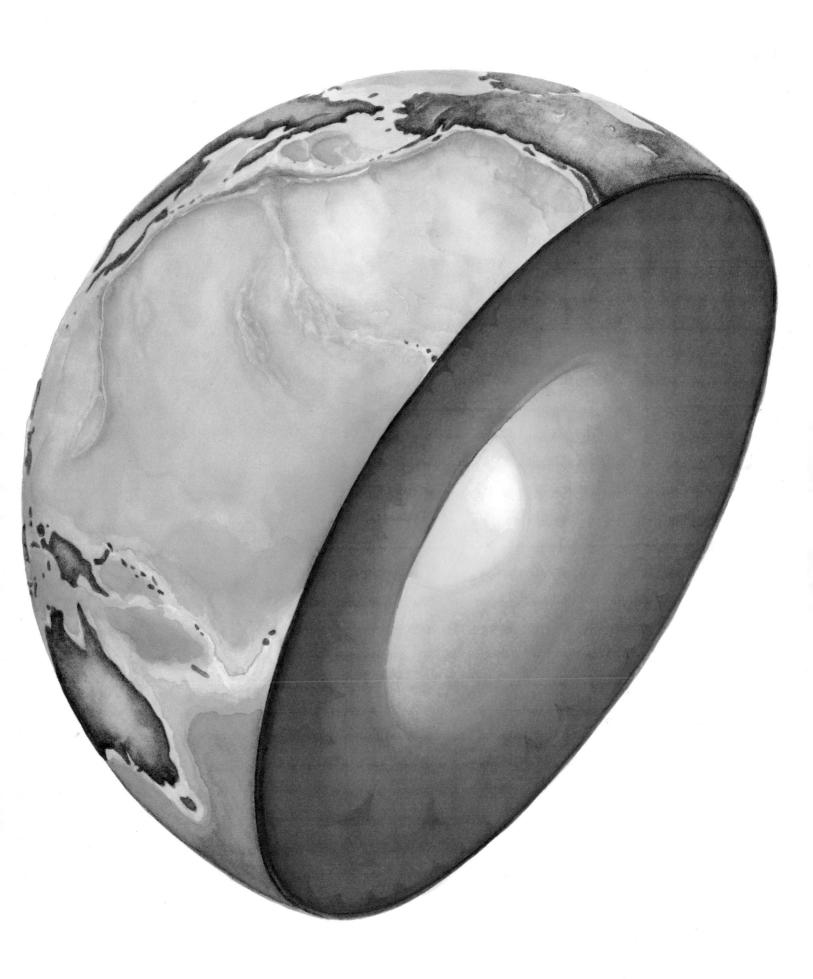

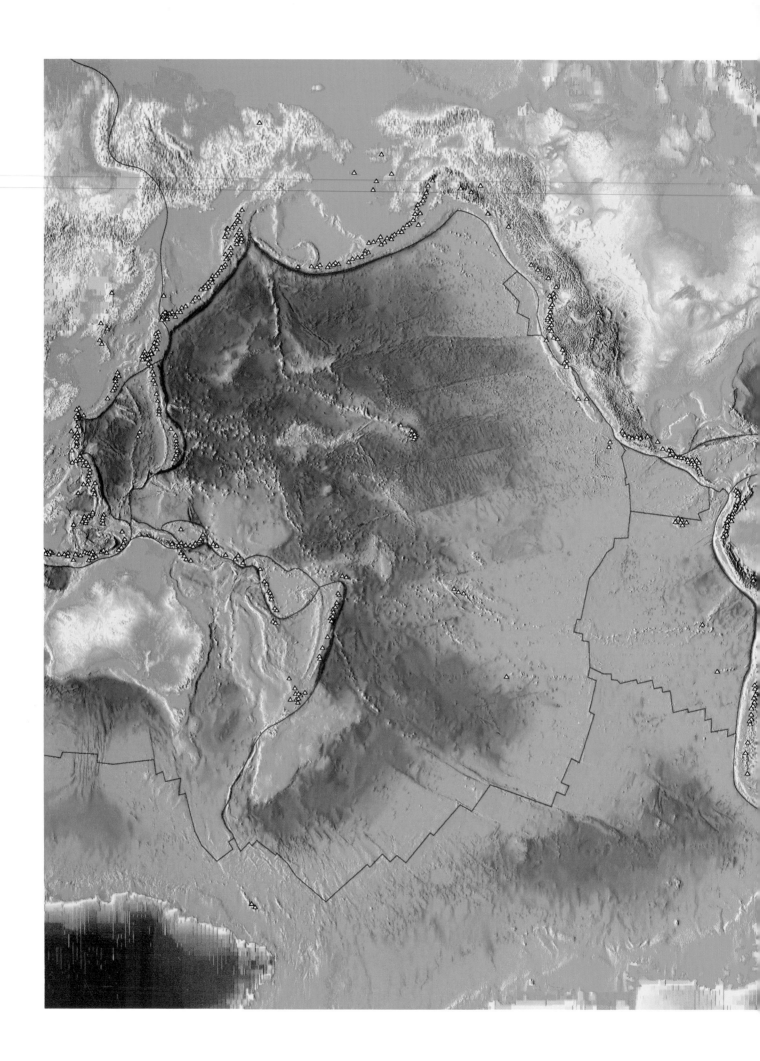

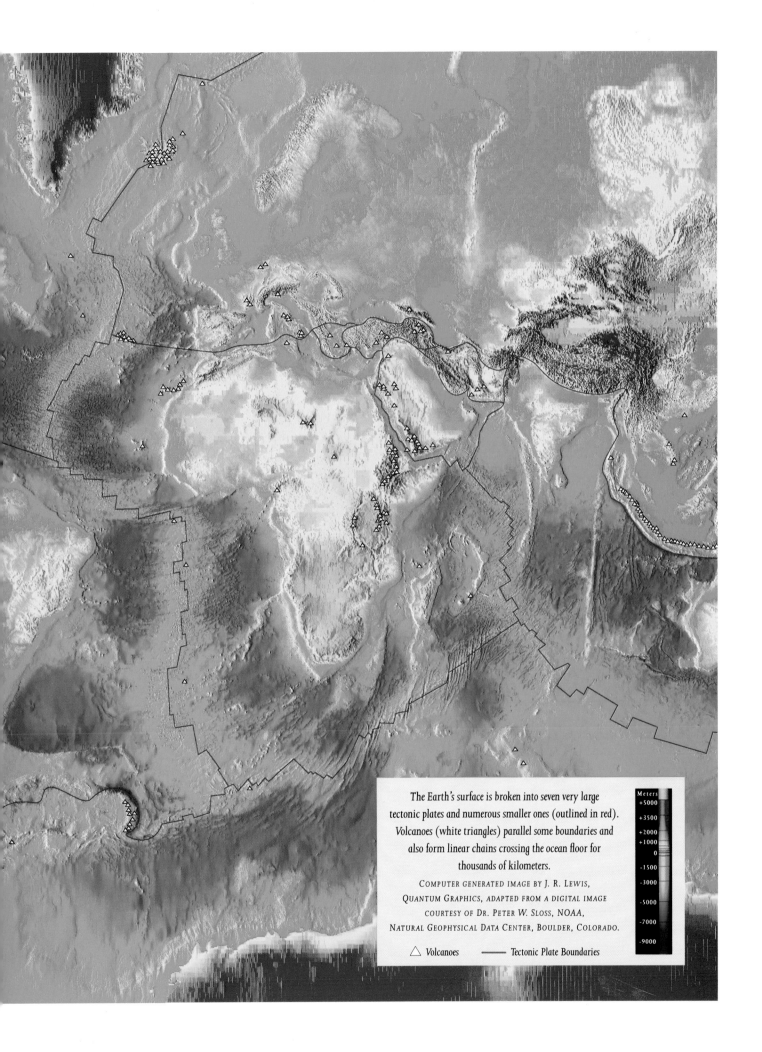

The Earth's surface is broken into seven very large
tectonic plates and numerous smaller ones (outlined in red).
Volcanoes (white triangles) parallel some boundaries and
also form linear chains crossing the ocean floor for
thousands of kilometers.

COMPUTER GENERATED IMAGE BY J. R. LEWIS,
QUANTUM GRAPHICS, ADAPTED FROM A DIGITAL IMAGE
COURTESY OF DR. PETER W. SLOSS, NOAA,
NATURAL GEOPHYSICAL DATA CENTER, BOULDER, COLORADO.

△ Volcanoes ——— Tectonic Plate Boundaries

Meters
+5000
+3500
+2000
+1000
0
-1500
-3000
-5000
-7000
-9000

Chapter 2

Roots of Volcanoes

Chapter 2

Roots of Volcanoes

Volcanoes are not unique to Earth. They are common features on all of the inner planets and have played an important role during their formation. Smaller bodies, such as Earth's moon, cooled so rapidly that volcanism ended while meteor impacts were still common. For this reason, most of the volcanic features on the moon have been obliterated by impact cratering. The larger planets cooled sufficiently slowly that volcanism continued long after the rate of impacting events declined. On Mars, volcanism ended about 200 million years ago, while its surface has continued to be reworked by occasional meteorite impacts. Volcanic activity on Venus has continued through the present with new volcanoes being created at about the same rate as old ones are destroyed by cratering. On Earth, the largest and most volcanicly active of the inner planets, more than half of the surface is younger than 200 million years. Erosion and volcanic resurfacing is occurring at a much faster rate than cratering so that large impact features are rare.

Volcanoes on other planets provide some clues to understanding those on Earth. On Mars and Venus volcanoes appear to be evenly distributed. Volcanoes on Earth, however, generally occur as long, linear chains hundreds or thousands of kilometers long. This is because plate boundaries on Earth control the locations of volcanoes, whereas on Venus and Mars this is not the case. If plate tectonics ever played a significant role on planets other than Earth, evidence for this has long since been destroyed by meteor craters.

Hundreds of active volcanoes dot Earth's surface. Some erupt often and passively, while others erupt every few millennia with the power of an atomic bomb. Some produce graceful rivers of molten rock, while others wrack their slopes with avalanches of incandescent rock. Despite these differences, most fall into two broad categories. One, known as shield volcanoes, forms long, linear chains of islands and seamounts stretching for thou-

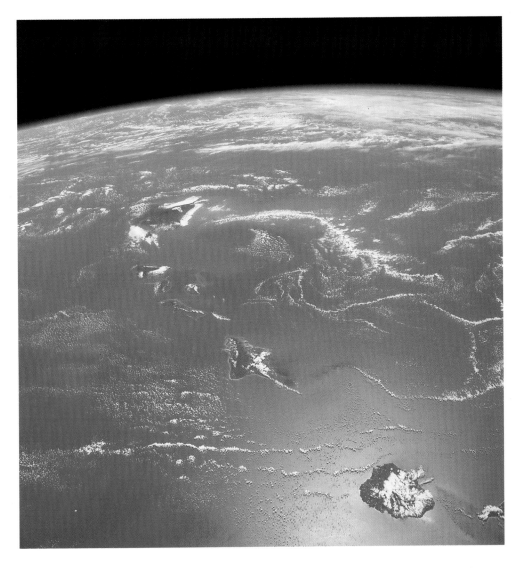

sands of kilometers across the ocean floor. These are similar to volcanoes on other planets. Shield volcanoes are formed from lava called basalt. Its source is the slowly melting rock in the upper mantle tens to hundreds of kilometers beneath the surface. Within the earth, melted rock is known as magma. Because the magma source lies below the moving plates, linear chains of volcanoes form as it repeatedly works its way to the surface.

Basalt originates near the top of Earth's mantle in a layer several hundred kilometers thick called the asthenosphere. This is the same layer within which currents moving slower than the growth rate of a human hair cause the motions of the tectonic plates. It might seem strange that rocks can be both solid and deformable at the same time. However, deep in the Earth, the effect of temperature and pressure are such that solid rock can flow slowly like a very thick fluid. This property is known as ductility. The motions are so slow that it takes millions of years for the movement to become significant.

Both rising and descending currents are found within the asthenosphere, much like the convecting flow in a pot of boiling water. Basaltic magma is formed at what are called "hot spots," where rising currents are most concentrated. Only a small percent of the mantle material is melted to produce basalt, initially as a mixture of crystals and molten rock. As the magma is squeezed out of this mixture by tremendous pressures, it forms large pods which are lighter than the surrounding rock. Eventually the pods of magma become sufficiently large that they begin moving slowly towards the surface in a tadpole-

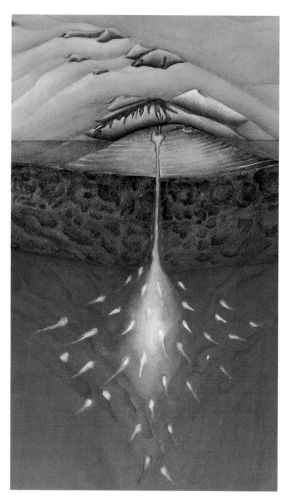

ABOVE

"Hot spot" volcanoes, like those in Hawaii, are a continuation of the cooling of planet Earth. The magma for these volcanoes is derived in the uppermost mantle by the partial melting of rocks as they are carried upward by slow mantle currents. Because the magma is lighter than the surrounding rocks, it has a natural tendency to rise. Linear chains of volcanoes are formed when a hot spot underlies a moving tectonic plate.

PAINTING BY MARIAN BERGER.

shaped form known as a diapir. Diapirs rise by pushing the ductile rocks aside to make way for their passage.

Eventually diapirs reach less deformable rock about 60 kilometers thick known as the lithosphere. The lithosphere is broken into 12 large tectonic plates and a few smaller ones. Unable to push the brittle, shallower rock aside, diapirs can rise no farther. Instead, magma enters a series of disk-shaped, vertical cracks a few meters wide and several kilometers in diameter. These cracks open and close as batches of magma migrate from one to another moving steadily upward. Thus magma rises to within a few kilometers of Earth's surface.

The upper mantle magma, lighter than the rock surrounding it, has a natural tendency to rise. Closer to the surface, however, it encounters rock lighter than itself and its slow ascent is halted. A large chamber forms as magma pools at a depth of a few kilometers below the surface. This magma chamber is like a gigantic rock balloon several kilometers across, inflating as fresh magma arrives from below until the pressure forces it to erupt onto the volcano's surface. As a shield volcano grows, its magma chamber rises as well, always staying a few kilometers beneath the summit. Basaltic lava is very fluid, and the smaller amount of dissolved gas it contains easily escapes. Consequently, eruptions of basaltic shield volcanoes are generally less explosive than those of other volcanoes.

The other major type of volcano parallels plate boundaries where two tectonic plates collide. As one plate, always an oceanic plate, is pushed beneath another, water-saturated sediments deposited on the ocean floor and portions of the plate itself are remelted to form a very thick, sticky magma known as andesite. Stratovolcanoes form on the stationary plate above the melting, subducted sediments. Ranges of stratovolcanoes bound the Pacific Ocean basin in a belt of active volcanism known as the "ring of fire." The stationary plate may either be ocean floor, such as in the Aleutian Islands or Japan, or continental, such as in the Cascade Range of the Pacific Northwest or the Andes of South America. Stratovolcanoes are more frequently dangerous, punctuating human history with their tales of destruction. Names like Krakatau, Vesuvius, Mount St. Helens, and Pinatubo spring to mind, although there are hundreds more. Stratovolcanoes are unique to planet Earth, indicating that plate tectonics is not an important process on other planetary bodies.

Stratovolcanoes often provide ample warning before an eruption. Thick magma migrates upward, and earthquakes shake the area as rock is shattered to make way for its

passage. Nearing the surface, water trapped in shallow crustal rocks boils, and white clouds of steam billow from widening cracks for days or weeks preceding an eruption. Shallow steam explosions shower the upper slopes with rocky debris. Sometimes a dome of pasty, thick magma is extruded at the summit—a sure sign that an eruption is imminent. At the beginning of an eruption, ash and fragments of old lava are blasted tens of kilometers into the atmosphere forming a gigantic column of gas and steam frequently charged with lightning. Dust and sulfur dioxide injected into the upper atmosphere can change global weather patterns for years.

Stratovolcanoes are generally much smaller and shorter-lived than basaltic shields, completing their growth in 50,000 years. Structurally very weak, stratovolcanoes erode and disappear quickly. During the lifetime of a shield volcano such as Mauna Loa in Hawaii, several generations of stratovolcanoes will grow and erode away. Stratovolcanoes also erupt much less frequently than their basaltic shield cousins, although often more dramatically. Because they are concentrated along densely populated coastal regions, stratovolcanoes have always presented a serious hazard to mankind.

BELOW
Eruptions of shield volcanoes often begin with a fissure event, forming a "curtain of fire" lasting for hours or days. People gather from all over the world to experience these scenes of fiery splendor.

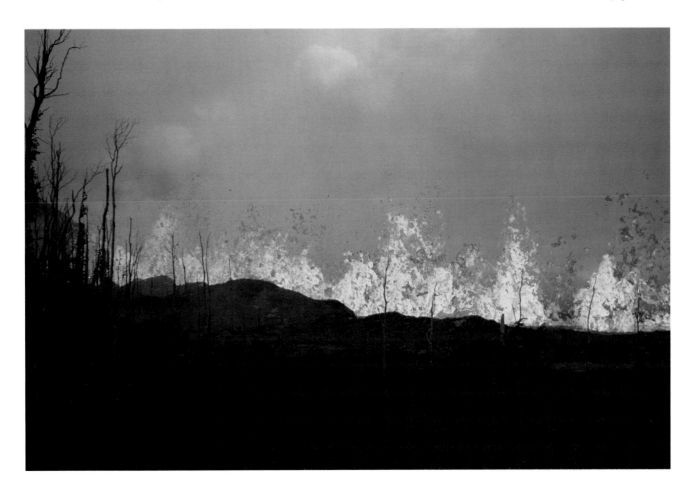

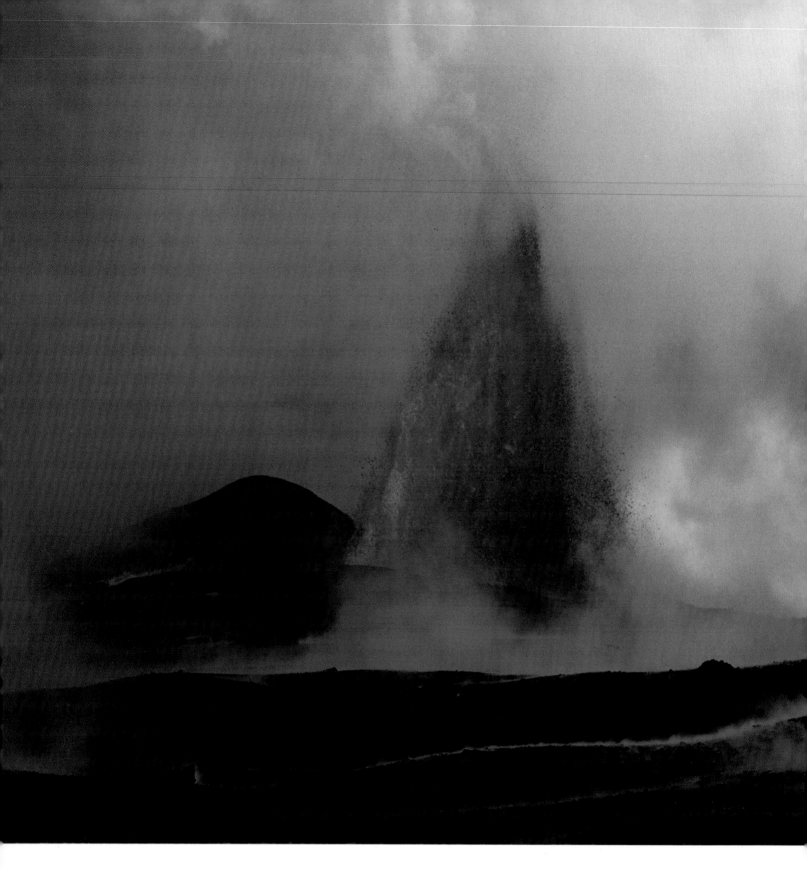

ABOVE
Fountains of molten rock jetting hundreds
of meters into the air are one of many
spectacular displays produced during
eruptions of shield volcanoes.

3 0 FIRE ON THE MOUNTAIN

Sheets of molten rock cut through
the forest, only to cool and add
yet one more layer to the
structure of a shield volcano.

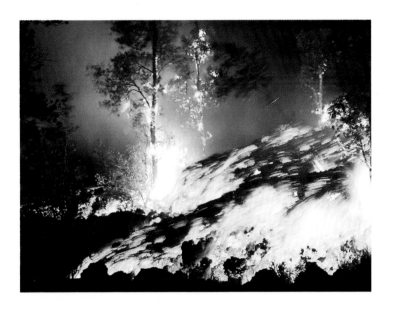

ABOVE

Rivers of lava encased in stone flow
beneath the surface of a shield
volcano. Bright red lava is revealed
as a small section of roof collapses.

Stratovolcanoes like Mount St. Helens (lower left) are the second major type of volcano on Earth. They often appear more rugged than shield volcanoes when viewed from space. Trees were stripped from the volcano's slopes by a tremendous blast of volcanic gas and ash accompanying an eruption in 1980. The light brown lines radiating outward show where rivers of hot mud swept down valleys as glacial ice was quickly melted by hot ash. On the right, Mt. Adams (lower) and Mt. Rainier (upper) lie near the axis of the Cascade Range, a line of stratovolcanoes paralleling the Pacific Coast. COURTESY NASA.

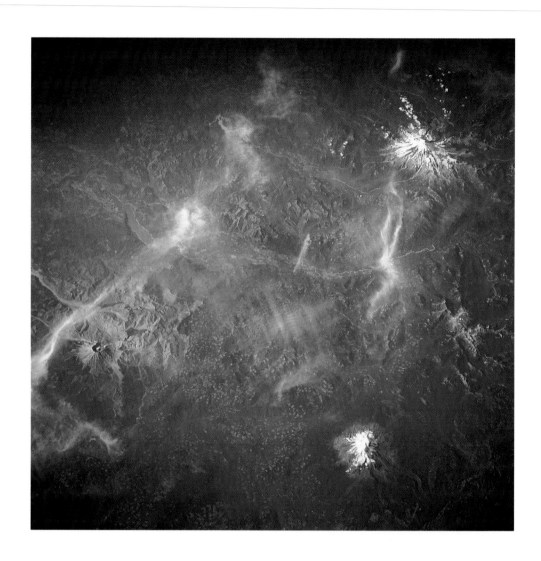

Stratovolcanoes form long ranges paralleling coastlines where one tectonic plate is pushed beneath another. Sediments on the ocean floor and portions of the descending plate are melted by the temperatures which increase rapidly with depth, and the resulting magma rises and erupts to form the volcanoes of the range. Stratovolcanoes are found where shallow mantle currents descend. PAINTING BY MARIAN BERGER.

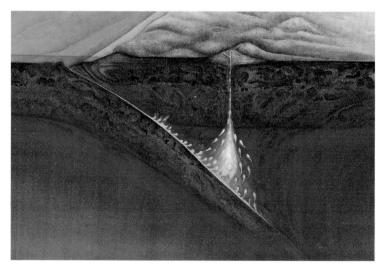

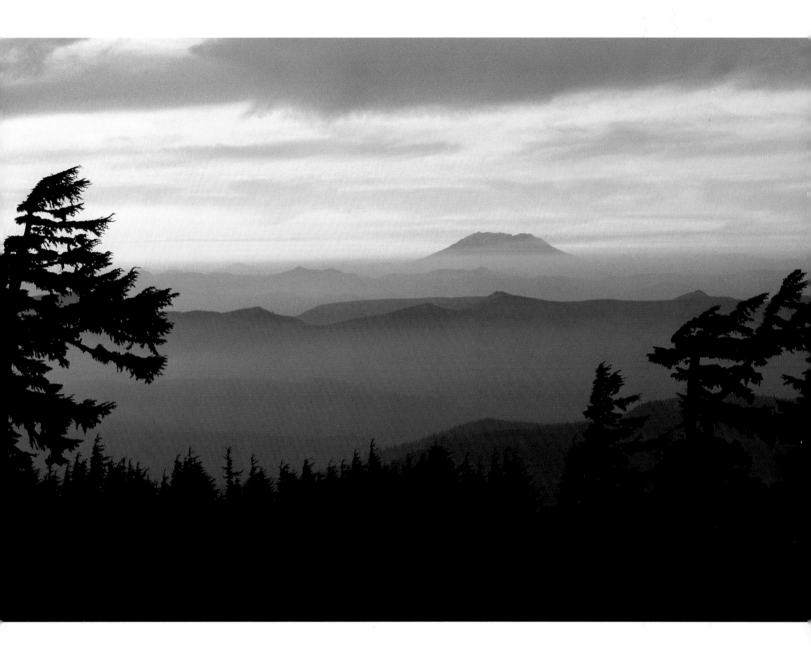

Stratovolcanoes, between eruptions, are some of the most picturesque and beautiful volcanoes on Earth. Such volcanoes can be still for thousands of years between violent eruptions that devastate the surrounding countryside. Despite their lofty aspect, stratovolcanoes tend to be much smaller than shield volcanoes, with maximum elevations of only a few kilometers as compared to Mauna Loa, with a height of approximately 10 km. PHOTOGRAPH BY STEVE TERRILL.

Eruptions of stratovolcanoes, like the one on Alaska's Augustine Volcano on March 31, 1986,
often begin explosively with a blast of hot gas and ash streaming at near supersonic velocity into
Earth's atmosphere. As the ash settles back to the earth, thousands of acres can be suffocated
under several meters of fine, gray ash. Smaller particles and volcanic gases circle the Earth for
years, altering global weather patterns. PHOTOGRAPH BY BETSY YOUNT, COURTESY USGS.

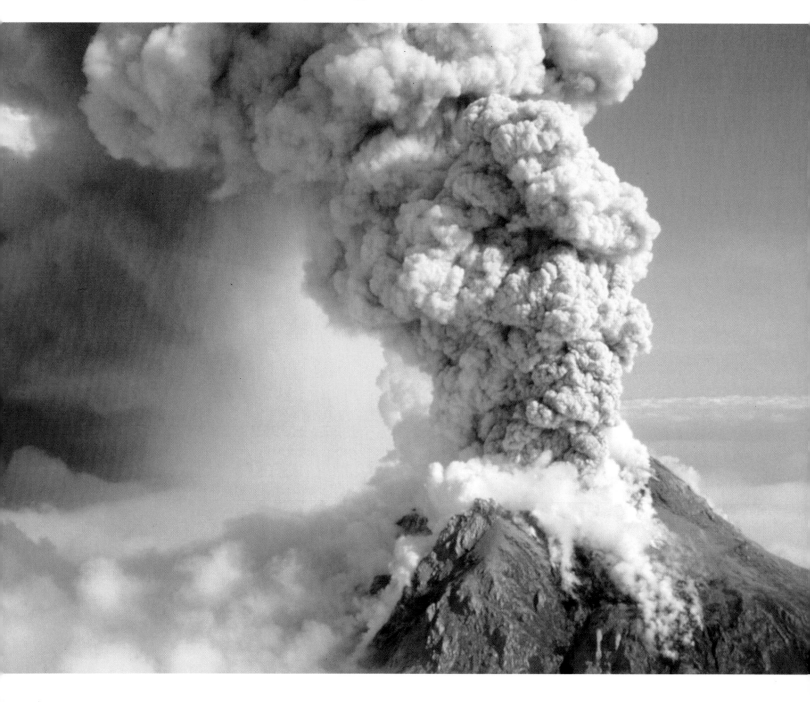

After the violence at the beginning of an eruption subsides,
much of the mass blasted away at the outset is replaced by a large dome
of very thick and cooler lava as occurred following a recent violent eruption of Redoubt Volcano
in Alaska. A volcanic dome is unstable, sometimes fragmenting into avalanches of hot gas
and ash that flow down a volcano's flanks, destroying everything in their path.

PHOTOGRAPH BY DAVID WIEPRECHT, COURTESY USGS.

Chapter 3

Volcanoes and Human History

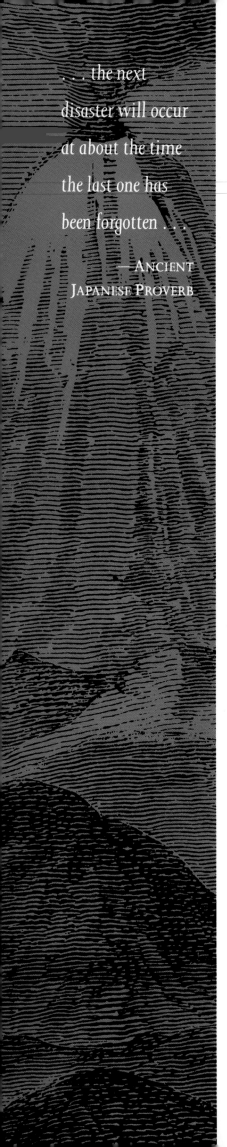

. . . the next
disaster will occur
at about the time
the last one has
been forgotten . . .

—ANCIENT
JAPANESE PROVERB

Chapter 3

Volcanoes and Human History

When Earth was young, volcanic activity was much more frequent than it is today. Once Earth's surface temperature had dropped below the boiling point of water, the spark of life caught in pools of mineral-rich water. Volcanic heat incubated early life as it evolved over billions of years through form after form of which we are but one. The earliest tools were made of volcanic glass, and from volcanoes some cultures learned of fire. But there were hazards as well, and civilizations were dealt major setbacks when volcanic activity became particularly destructive.

About 3,500 years ago, the Minoan culture thrived in the eastern Mediterranean. Akroteri on the island of Santorini was one of its spiritual centers. The city clung to the side of Thera Volcano on the crescent shaped island, which itself was the result of a tremendous volcanic explosion centuries before. Alerted by a series of earthquakes, the citizens of Akroteri had ample time to escape. The maritime Minoan civilization, occupying many of the islands in the Aegean Sea, however, was devastated by the tsunami following the explosive destruction of Santorini. Never fully recovering from the catastrophe, it was subsequently overrun by armies from the North, and Minoan history was woven into Greek mythology. Many archaeologists believe this was the event chronicled in the legend of Atlantis.

Almost 1,600 years later, on August 24, AD 79, history repeated itself, although this time somewhat less violently. Near the Bay of Naples, Mount Vesuvius roared to life after sleeping for centuries. For 16 years the area had been shaken by earthquakes, as thick, sticky magma moved ever closer to the surface, and to the moment that the cities of Pompeii, Herculaneum, and Stabiae would be destroyed. Despite the warnings, the people were caught unprepared, and thousands were buried beneath tons of ash and cinder.

A graphic account of the horror of that day is preserved in a letter written to a friend by a young man named Pliny, nephew of the famous Roman naturalist of the same name.

My uncle was stationed at Misenum, in active command of the fleet. On 24 August, in the early afternoon, my mother drew his attention to a cloud of unusual size and appearance . . . its general appearance can best be expressed as being like an umbrella pine, for it rose to a great height on a sort of trunk and then split off into branches . . . Ashes were already falling, hotter and thicker as the ships drew near, followed by bits of pumice and blackened stones, charred and cracked by the flames . . . on Mount Vesuvius broad sheets of fire and leaping flames blazed at several points, their bright glare emphasized by the darkness of night . . . By now it was dawn, but the light was still dim and faint. The buildings round us were already tottering, and the open space we were in was too small for us not to be in real and imminent danger if the house collapsed. This finally decided us to leave the town (Pompeii). . .We also saw the sea sucked away and apparently forced back by the earthquake: at any rate it receded from shore so that quantities of sea creatures were left stranded on dry sand. On the landward side a fearful black cloud was rent by forked and quivering bursts of flame, and parted to reveal great tongues of fire, like flashes of lightning magnified in size.

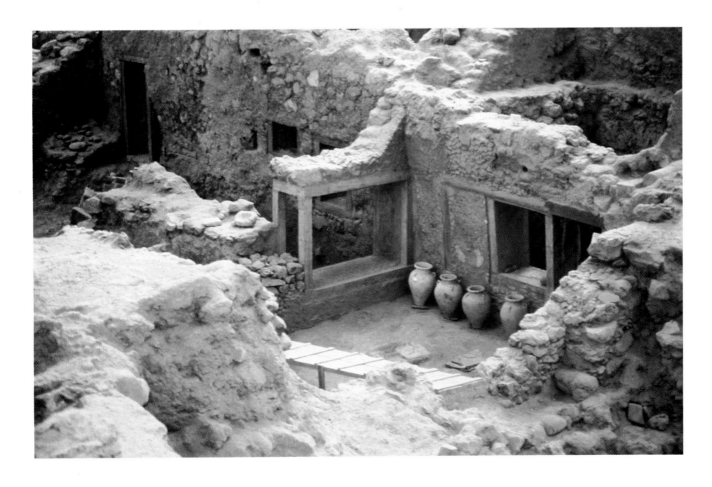

Since that time Vesuvius has remained active, and tens of thousands have perished during numerous smaller eruptions. Today the suburbs of Naples have reached out to embrace their treacherous neighbor and thousands live on the flanks of the sleeping giant.

The danger of volcanoes was introduced to the Americas with the eruption of Mt. Pelee on May 8, 1902. A glowing avalanche broke from an expanding dome near the summit of the volcano and descended on St. Pierre on the French Caribbean island of Martinique, killing all but two of the 30,000 residents. Again, the mountain gave ample warning of its intentions. Four months before the catastrophe, sulfurous fumes were detected on the slopes of the volcano. Two months later, earthquakes had become large enough for plates and dishes to be sent crashing to the floor. A lake near the summit, dry for many years, filled with boiling water. During the final week, a vast, black cloud, laced with lightning, hung over the city. An invasion of poisonous, yellow-brown snakes escaping the volcano's unrest descended on the town, killing more than 50 people and 200 domestic animals. Again the warnings were generally ignored. One who did not was Marino Leboffe, captain of the Orsolina out of Naples, Italy, who was reported to have said:

I know nothing about Mount Pelee, but if Vesuvius were looking the way your volcano looks this morning, I'd get out of Naples.

The next morning when Mt. Pelee pelted St. Pierre with incandescent ash and hot gas, Captain Leboffe was far out to sea, one of the few to escape the devastation. Indeed, many of those who tried to leave by land were turned back by troops stationed on the roads leading out of town, because their votes were needed to tip the upcoming elections in favor of the incumbent administration. Early on the morning of May 8, the town lay lifeless and utterly destroyed beneath a scorching, hot blanket of ash. The world was shocked and responded by sending aid to those in the surrounding countryside who had survived the devastating eruption. Two weeks later, arriving from New York with a group of other scientists and journalists, Thomas Jaggar of the Massachusetts Institute of Technology was astonished by the completeness of the destruction.

BELOW
Deep layers of pumice, a very airy form of volcanic rock, exposed in a cliff, tell of previous catastrophic eruptions of Thera Volcano. Great volumes of pumice often precede the earthshaking steam explosions that can leave a great, gaping crater where a volcano once stood.
PHOTOGRAPH BY ROBERT DECKER.

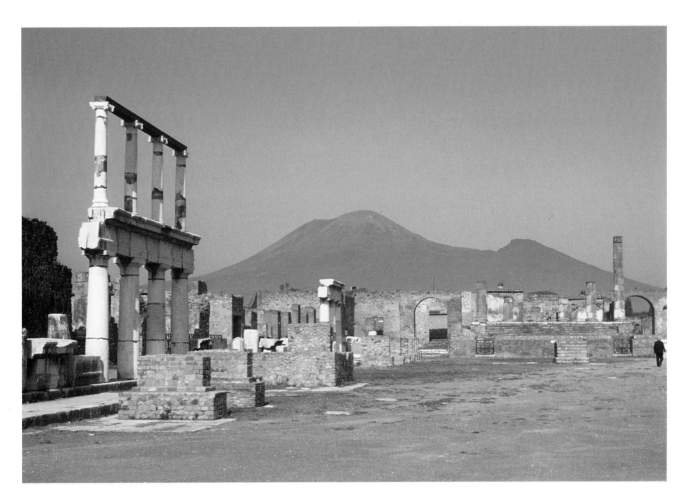

A geophysicist studying both volcanoes and experimental geology, Jaggar was so moved by this scene of human destruction that he dedicated his life to the study of volcanoes for the protection of the people of the world. After searching the world for a suitable site for his studies, Jaggar finally settled on Kilauea Volcano on the island of Hawaii. Following his founding of the Hawaiian Volcano Observatory at the summit of Kilauea Volcano, Jaggar asserted:

> There is no place on the globe so favorable for systematic study of volcanology and the relationships of local earthquakes to volcanoes as in Hawaii . . . where the earth's primitive processes are at work making new land.

The motto of the new laboratory of Earth's volcanic processes was "Ne plus haustae aut obrutae urbes"—"No more shall the cities be destroyed." Today, perched on the rim of Kilauea's summit caldera, and overlooking a scene of immense devastation and beauty, the Hawaii Volcano Observatory keeps Jaggar's dream alive.

ABOVE
The city of Pompeii was buried beneath tons of ash when, after centuries of quiescence, Mt. Vesuvius erupted in AD 79. Today, the continuing excavation of Pompeii provides a unique window into life during the first century.
PHOTOGRAPH BY ROBERT DECKER.

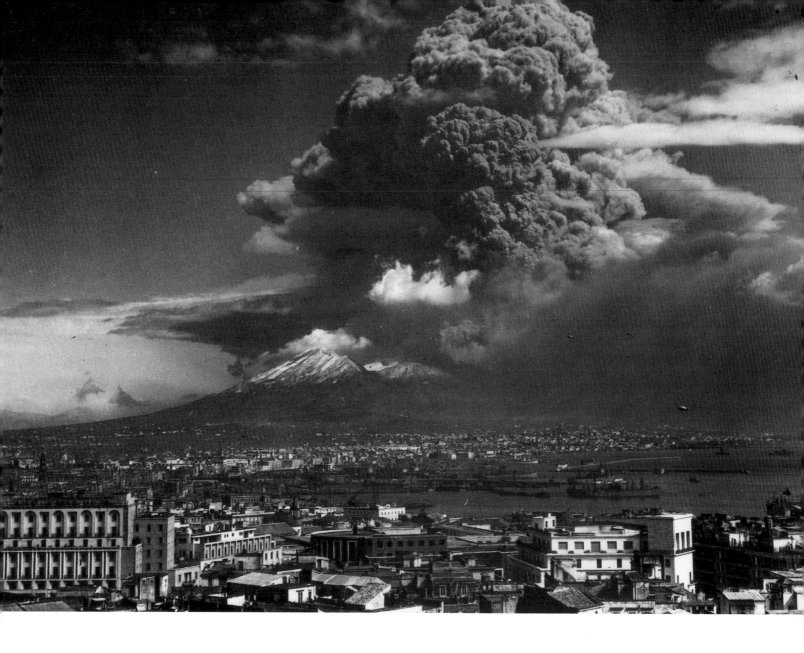

RIGHT
Throughout history, eruptions
of *Vesuvius Volcano* have taken
a heavy toll in both lives and
property. The explosive
eruption of 1906 reduced the
mountain's height by nearly
200 meters, as tons of ash were
spread over the surrounding
countryside. A considerable
amount of this material ended
up in the streets of Ottaviano,
where it had to be arduously
removed by hand and
horse-drawn carts.
COURTESY LIBRARY OF CONGRESS.

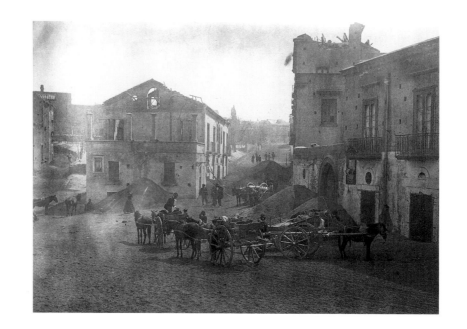

LEFT
Today the suburbs of Naples, Italy, crowd the slopes of Mt. Vesuvius closer than the ancient ruins of Pompeii. The column of ash that towered above the city in 1944 is a reminder of future, more devastating eruptions yet to come. COURTESY U.S. NAVY, NATIONAL ARCHIVES.

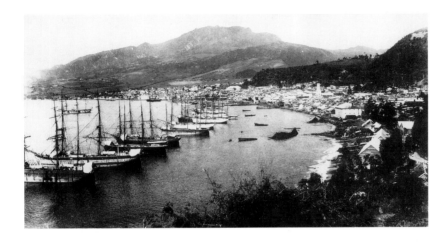

TOP
The tranquil town of St. Pierre on the Caribbean island of Martinique slumbers under a warm, tropical sun at the foot of Mt. Pelee several years before the catastrophic eruption in 1902. Few suspected the devastating fury that would be unleashed. COURTESY ROYAL COMMONWEALTH SOCIETY.

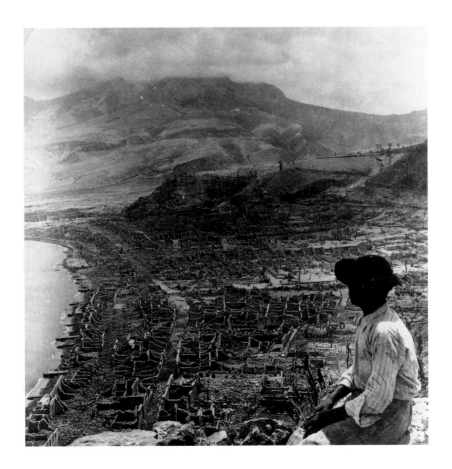

BOTTOM
From the same viewpoint, only memories remain as St. Pierre lies utterly destroyed following the eruption. Of 30,000 inhabitants in 1902, only two survived the avalanches of incandescent ash that leveled the city. This scene of devastation led Thomas Jaggar, a professor of geology from M.I.T., to found a laboratory in Hawaii for understanding volcanoes so that, in his words, "no more shall the cities be destroyed." COURTESY LIBRARY OF CONGRESS.

The earliest buildings of Jaggar's laboratory at the
summit of Kilauea Volcano may seem crude by
today's standards, but the contributions that have
followed from these modest beginnings have led to
the saving of thousands of lives throughout the
world. The Hawaiian Volcano Observatory, now
operated by the U.S. Geological Survey, keeps
Jaggar's dream alive as a center for scientists who
come from all over the world to unravel the secrets
of the world's volcanoes. COURTESY USGS.

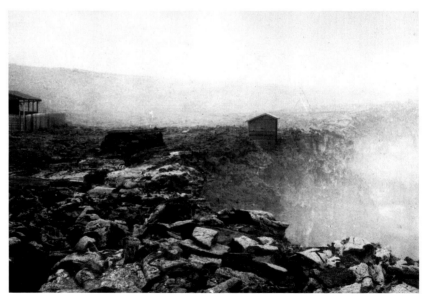

When Thomas Jaggar came to Kilauea Volcano in
Hawaii, the summit region was a very different
place than it is today. A turbulent lake of molten
rock had been present since it was first depicted by
Titian Ramsey Peale in 1842, and was thought to
be a permanent feature of Kilauea Volcano.
PAINTING BY TITIAN RAMSEY PEALE, COURTESY
BISHOP MUSEUM.

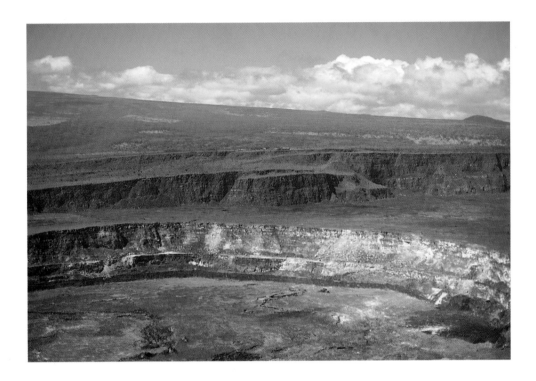

Today the summit of Kilauea
no longer contains a long-lived
lava lake. Perched on the rim
of the summit caldera, the
Hawaiian Volcano Observatory
is dwarfed by the grandeur
of Kilauea's summit. The
broad, low profile of Mauna
Loa Volcano, behind, is typical
of shield volcanoes throughout
the world.

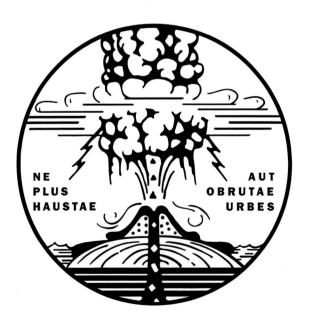

NE
PLUS
HAUSTAE

AUT
OBRUTAE
URBES

The original seal of the volcano observatory at
Kilauea's summit with its Latin motto, which
translates as "no more shall the cities be
destroyed," reveals Jaggar's deep devotion to
reducing the threat of volcanoes to the people
of the world. ADAPTED FROM THE ORIGINAL BY
J. R. LEWIS, QUANTUM GRAPHICS.

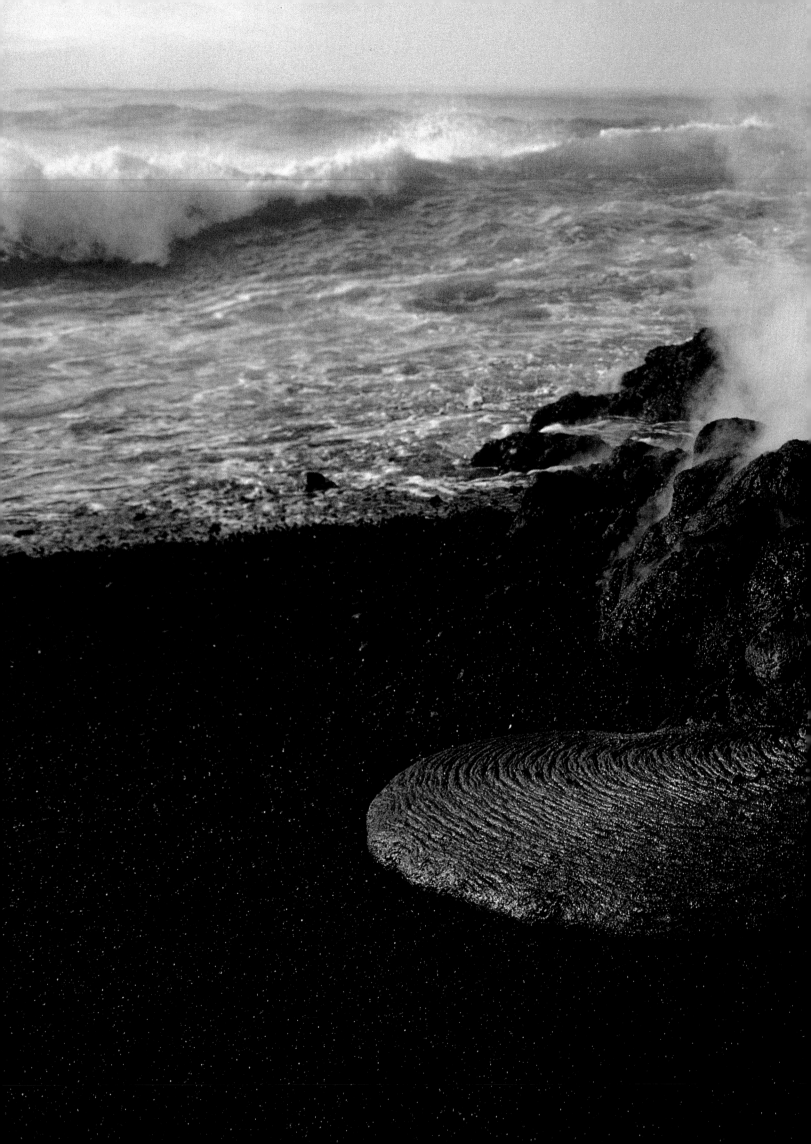

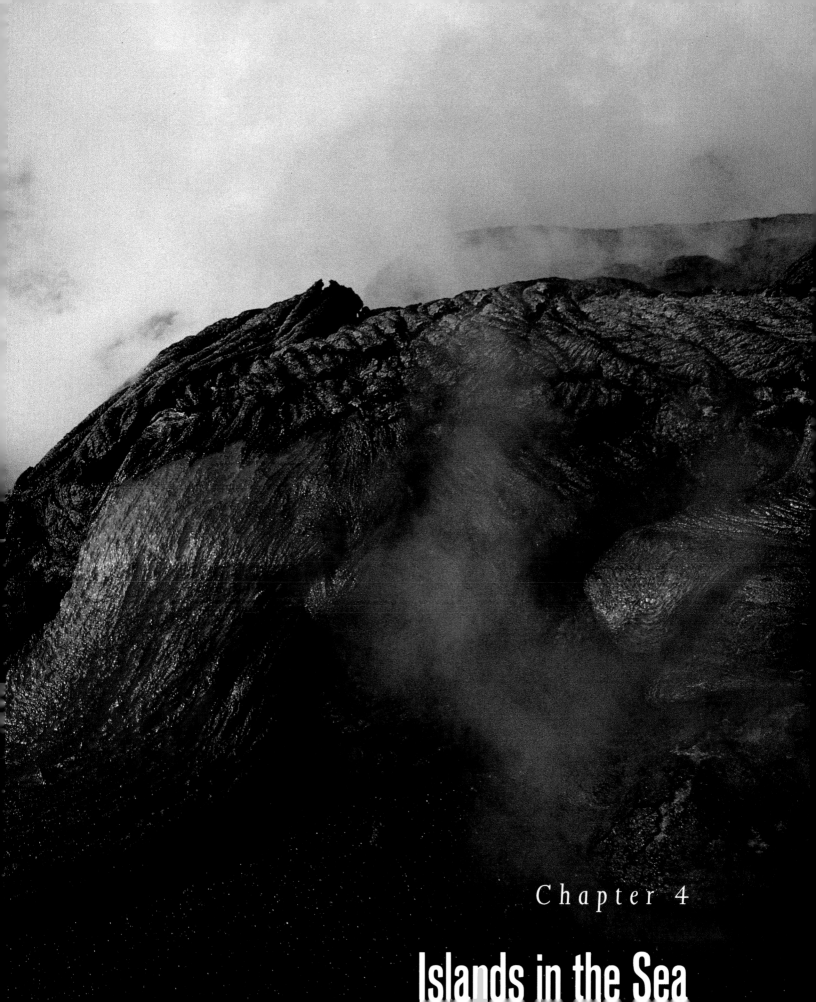

Chapter 4

Islands in the Sea

Chapter 4

Islands in the Sea

Jaggar chose the shield volcanoes of Hawaii as the site for his new observatory for two important reasons. First, their frequent eruptions provide ample opportunities for studying the eruptive process. Second, the eruptions of shield volcanoes are relatively safe because the basaltic magma most often erupted by shield volcanoes is very fluid. Even though there is a considerable amount of dissolved gas, it can easily bubble out of the lava before pressures become explosive. Stratovolcanoes, by contrast, tend to erupt violently after hundreds or thousands of years of quietude. Landslides and avalanches are primary forces in the construction of stratovolcanoes, whose unstable flanks make access to the summit and vent areas extremely hazardous. It is small wonder, then, that Jaggar settled on the volcanic island of Hawaii for his laboratory of volcanology.

For many basaltic shield volcanoes, the story of their growth begins at the bottom of the sea. There, the temperature is nearly cold enough to freeze water. Darkness prevails, for no sunlight can penetrate five kilometers of ocean to illuminate the depths. A volcano is born as a crack opens on the ocean floor and a flood of fluid lava spills out from it, beginning the building process. This first outpouring is vigorous, as pent up pressures needed to drive the magma upward through many kilometers of solid rock are suddenly released.

The growth of the new volcano from the bottom of the ocean takes hundreds of thousands of years. In the process, pillow lavas instead of sheet flows are formed. Pillows develop when the surface of a cooling flow cracks, and hot, molten material swells into a bulbous mass until its rind becomes too stiff and cold to permit further expansion. Loosely stacked one upon the other, the structure of the growing underwater volcano is weak and unstable. Again and again it collapses back onto the sea floor. With each collapse the base broadens, and the pile of pillow lava grows a little higher before collapsing again. Eventually, the summit of the growing volcano nears the surface of the ocean. No longer

do the tremendous pressures of the ocean depths keep the gas trapped within the magma from expanding.

Eruptions become explosive as a new volcanic island emerges from the sea. At first the new island is no more than a horseshoe-shaped pile of ash and volcanic fragments. When water contacts the molten lava in the vent, violent explosions shake the newly formed island sending small landslides down its flanks. As long as water has access to the vent, violent explosions continue. If the eruption were to stop, waves would quickly wash the loose pile away. But when the eruptions continue long enough, they change to a style known throughout the world as Hawaiian. Fluid sheets of lava spread over the loose pile of volcanic ash, cooling to a dense, hard surface. Thus armored, a new volcanic island can withstand the ravages of the ocean.

As the volcano continues its growth above the sea, its slopes become gentler because air cools the lava more slowly than does water. Thousands upon thousands of layers, each only a few meters thick, are stacked one upon the other as the island slowly rises above the waves. Each flow covers but a small part of the volcano's flank. As it grows higher, it also grows in extent as flows reach the sea and add a few more acres of new land to the shoreline.

The summit of an active shield volcano rises and falls above a magma chamber two or three kilometers deep. It rises a few centimeters as fresh magma enters it from a deeper source, then drops rapidly during eruptions. Deep collapse pits form on its surface as magma vacates shallow chambers during an eruption, leaving part of the summit unsupported. The largest of these form a summit caldera, a large crater several kilometers across, that sometimes can become the site of an enormous lava lake.

The rhythm of the summit varies with time. It may rise and fall in a single day or change so slowly as to be barely detectable. As it rises, the

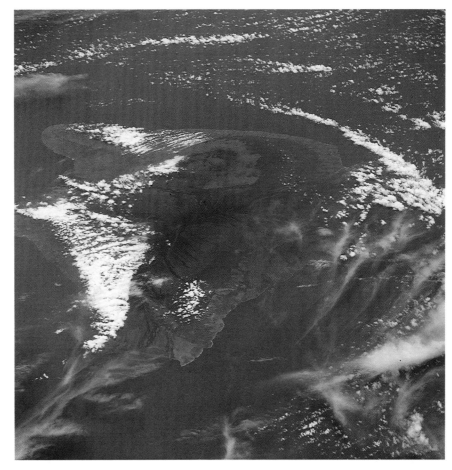

rock above the summit magma chamber creaks and shakes with thousands of tiny earthquakes. So much lava can be drained from the summit magma chamber during an eruption that water in the surrounding rocks can enter, creating a gigantic "steam boiler" explosion. At such times, a column of ash and steam rises tens of kilometers into the air, and large rocks and debris rain down upon the land. Fortunately, such activities are rare.

Eruptions of shield volcanoes usually occur along deep fracture zones that radiate from the summit. On Hawaiian volcanoes, these fracture zones are concentrated in two narrow bands called rift zones. During an eruption along one of the rift zones, magma fills a long, thin vertical crack called a dike. The dike, only a few meters thick but several kilometers high, slowly extends from the summit as pressure within pries the rock apart at its leading edge. Eventually the expanding dike breaks through to the surface and an eruption begins. Nearly all eruptions of shield volcanoes begin with fountains of molten rock ejected along a crack several kilometers long. This display is known as a "curtain of fire."

The force behind a "curtain of fire" is the expansion of water vapor, or steam. This is the last major gas to come out of solution as magma nears the Earth's surface. As magma rises, it expands into a bubble-rich froth greatly increasing its volume. The force from this rapid expansion causes lava to be ejected along the length of the fissure in a vertical sheet or a series of low coalescing fountains. The bubbles, called vesicles, are visible as small, spherical holes on a broken surface of solidified lava.

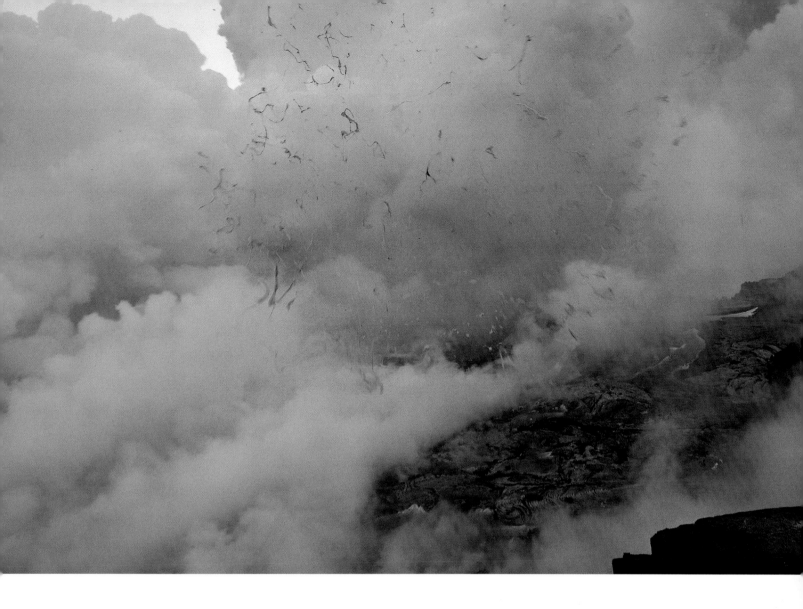

ABOVE

As the summit of a submarine volcano approaches the ocean's surface lava explodes through the waves, heralding the birth of new land from the sea.

Lava falling downwind of the fissure freezes into a wall of congealed blobs of lava called a spatter rampart. Such features are common along rift zones. Some eruptions end with the "curtain of fire," but many others continue in a series of eruptive episodes separated by days or weeks of quiet. Episodes of volcanic activity following the first one are somewhat different. As a "curtain of fire" ends, a cylindrical conduit, a pipe several meters wide and many kilometers deep remains, where the last of the lava flows from the fissure. Lava erupts in subsequent episodes as a "fire fountain." With all of the force propelling the eruption focused at a single narrow vent, streams of incandescent lava jet hundreds of meters into the air.

Fountaining begins tentatively, as degassed lava left over from the previous episode rises slowly within the conduit and flows sluggishly from the vent. When fresh magma makes its way up the conduit, the molten rock forms a dome falling back upon itself like water from a drinking fountain. The dome fountain continues to grow and eventually a fire fountain emerges that can be seen many kilometers away. The ground shakes and trembles violently as molten rock roars from a vent 20 meters wide. The lava cools as it is ejected, and solidified shards of lava fall back to the earth to form a growing cone of ash and cinder surrounding the vent. After several hours, the pressures driving the eruption begin to wane. The eruption subsides with occasional periods of renewed vigor, and lava drains back into the conduit, disappearing into the depths of the volcano.

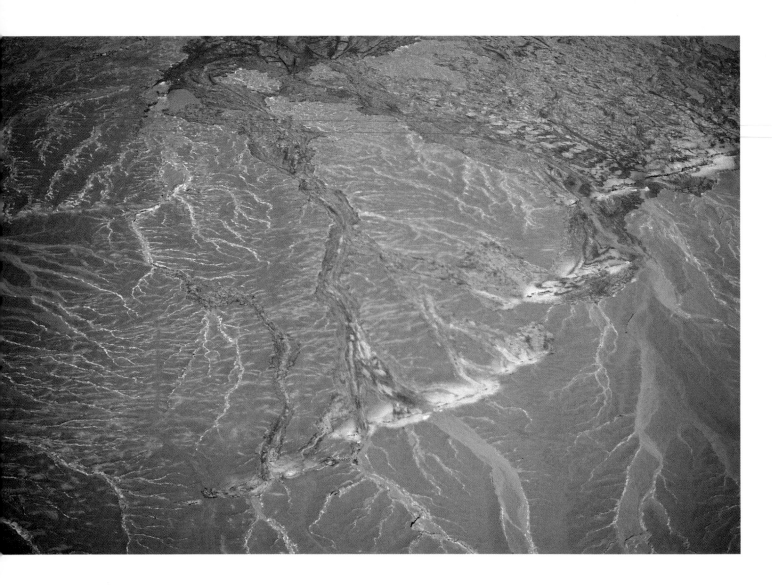

Lava from the base of both "curtains of fire" and "fire fountains" is cooled during its brief flight through the air and is purged of dissolved gases. Such flows freeze to a form known throughout the world by its Hawaiian name, a'a (AH-AH). A'a flows are lobed, rubbly heaps of loosely piled, jagged clinkers. Clinkers on individual flows tend to be uniform in size, although they vary from flow to flow ranging in size from a walnut to a small car. Because "fire fountains" and "curtains of fire" last only a few hours, a'a flows do not usually have time to travel great distances before cooling. Consequently, most a'a is found near the rift zones. The core of an active a'a flow is a flat tongue of thick, pasty lava that is sometimes exposed in the center of a flow. Some a'a flows are channeled, with rivers of cooling lava feeding an expanding front. As it advances, glowing clinkers tumble down its face with a sound like the tinkling of glass, occasionally revealing its dense, incandescent interior.

With each fire fountaining episode another layer is added to the cone. This can continue for years, until the style of the eruption changes again. As the shape of the vent evolves, erupting lava may no longer be able to gain the high velocities required to produce episodic fountains of fire. Lava then emerges from the Earth's interior as a passive flow, producing a long-lived lake of molten rock.

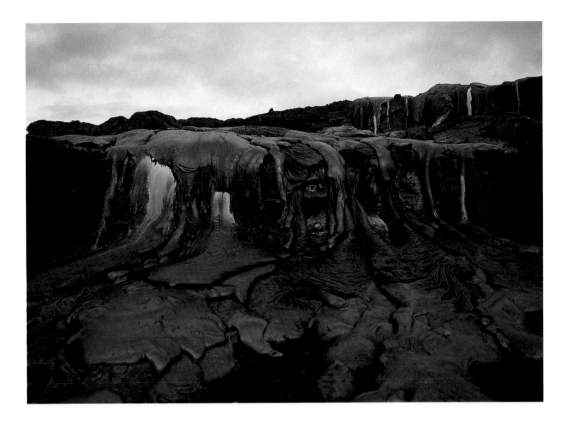

Layer by layer the volcano
grows, each layer formed
as ruddy sheets of lava
flood its surface. It takes
thousands upon thousands
of these layers before a
volcanic island reaches
its full height.

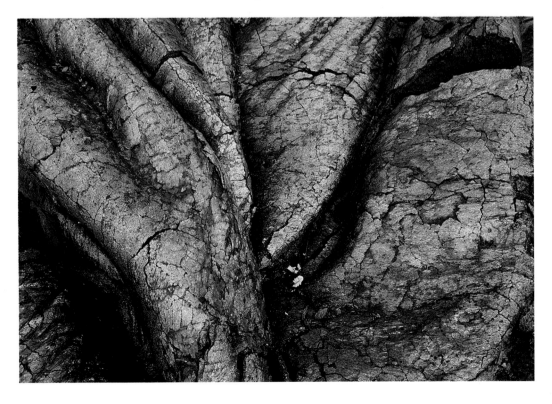

BOTTOM
Plants and animals from
older islands find their
way to new shores, and
life springs from the
barren rock. Native
Hawaiian plants and
animals are well-prepared
to make this move down
the island chain.

Eventually, luxuriant jungle covers a volcano's
lower slopes. Blackened corridors cut through
the trees by rivers of lava disappear within
decades as new growth spreads outward from
the forested margins of the flows.

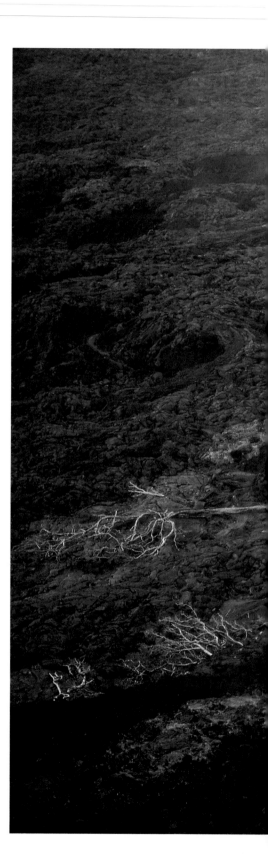

ABOVE
Life is sometimes a struggle on
an active volcano. The interplay
of lava and life engenders a
unique ecology.

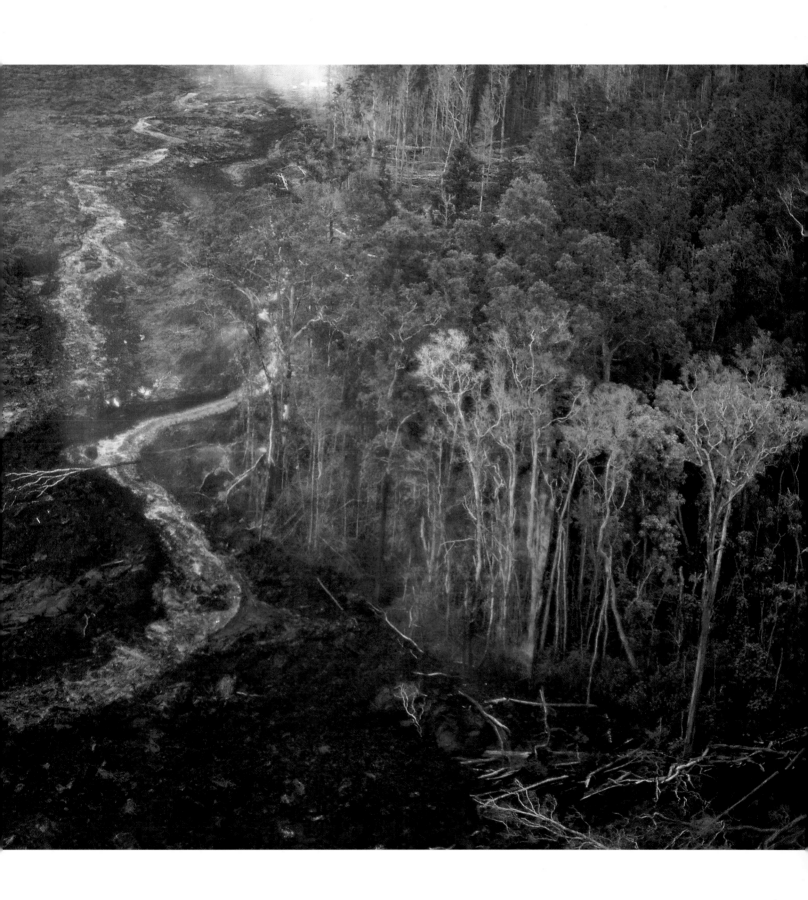

Pit craters form as shallow magma bodies drain away to feed distant eruptions, leaving the surface rock unsupported. Such features are common near the summits of shield volcanoes. Pit craters are ephemeral, lasting only until they are filled by subsequent eruptions.

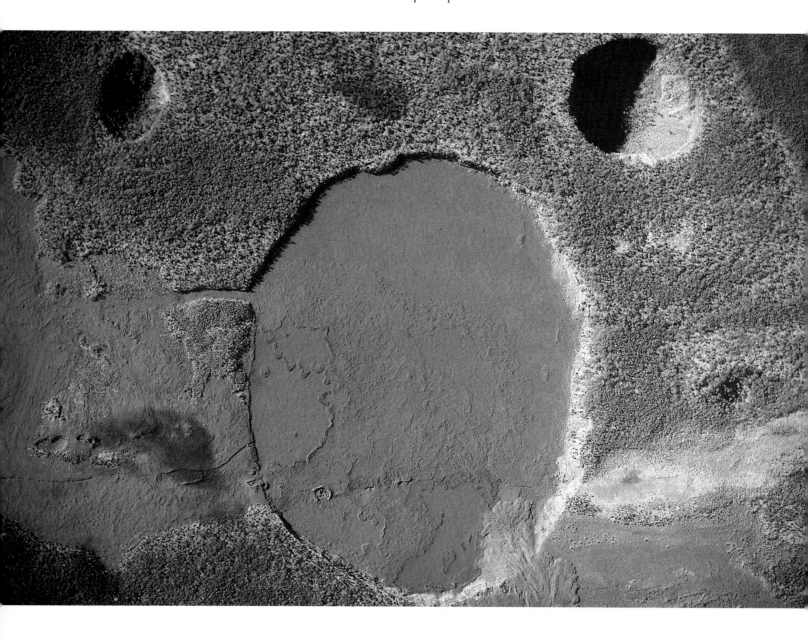

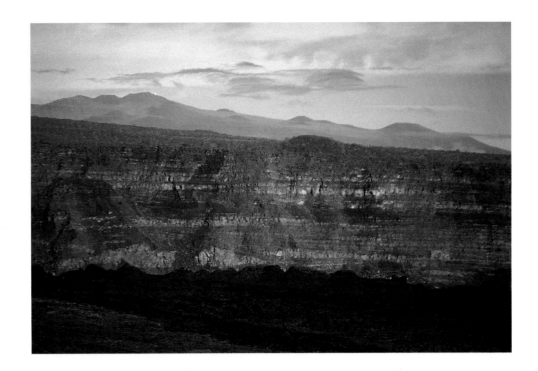

The layered structure of the
summit of a shield volcano is
obvious in the walls of the summit
caldera. The steeper flanks of
Mauna Kea Volcano on Hawaii,
behind, are built of the thick lavas
that erupted as its magma
chamber cooled.

BOTTOM

A recent eruption of Kilauea
Volcano on Hawaii lasted for more
than 10 years, leaving a blackened
scar of cooling basalt etched into
the verdant, green jungle. From a
vent (upper left) lava streams
through tubes beneath the surface
of the flow to the shore where new
land is being created at the base of
the billowing, white steam plume.

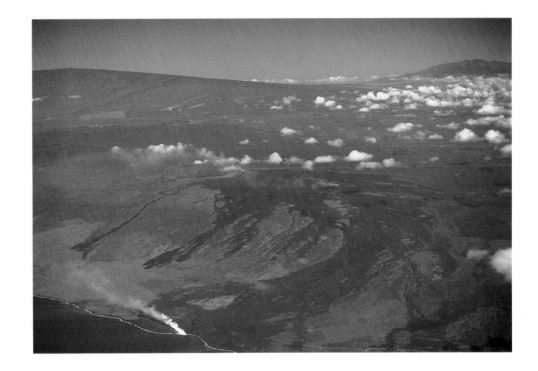

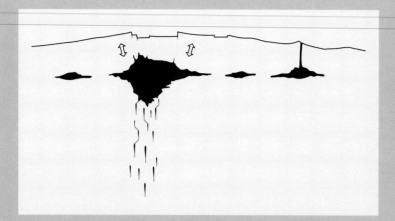

Between eruptions, magma accumulates in a large magma chamber beneath the summit of a shield volcano, as shown by the dark areas in the cross section (left). Sensitive instruments, known as tiltmeters, lie adjacent to the summit region and monitor the amount of stored magma by measuring subtle changes in tilt, the "heartbeat" of a shield volcano. These instruments, something like a very sophisticated electronic carpenter's level, can respond to tilt changes smaller than the thickness of a dime over a distance of one kilometer.

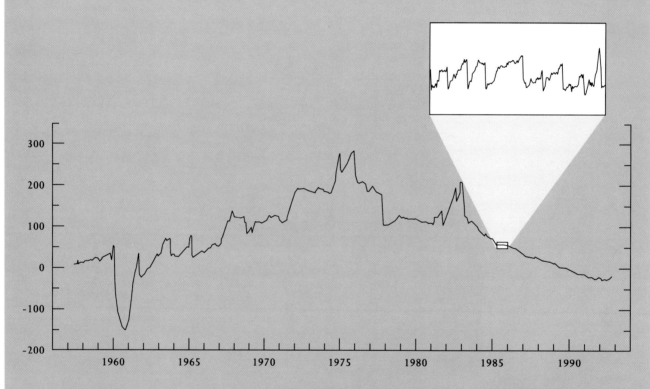

The large graph (above) shows the most significant changes in summit-stored magma over the past several decades. In this plot, sudden decreases in tilt correspond to major eruptive events. Smaller changes occurring over shorter times are also recorded by the summit tiltmeters. The expanded graph (upper right) shows a characteristic sawtooth pattern associated with the rapid fluctuations in tilt caused by a recent series of fountaining episodes. Periods of slow rise in this plot correspond to month-long intervals between episodes, as magma slowly accumulated in the summit reservoir from sources deep beneath the volcano. These periods of slow accumulation were then interrupted by rapid decreases in tilt as magma was erupted onto the volcano's surface over time periods that were generally less than 24 hours in duration.

COMPUTER GENERATED IMAGES BY J. R. LEWIS, QUANTUM GRAPHICS, FROM DATA COLLECTED BY THE HAWAIIAN VOLCANO OBSERVATORY.

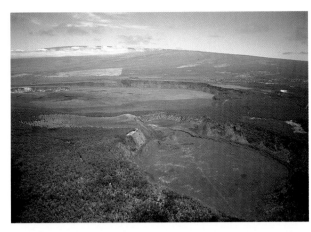

LEFT
The summit of a shield volcano rises and falls as the volume of lava stored in the summit magma chamber changes. When a substantial amount of magma is withdrawn during an eruption, the summit is left unsupported and huge collapse pits form. These pits coalesce to form a summit caldera, a hallmark of shield volcanoes throughout the solar system.

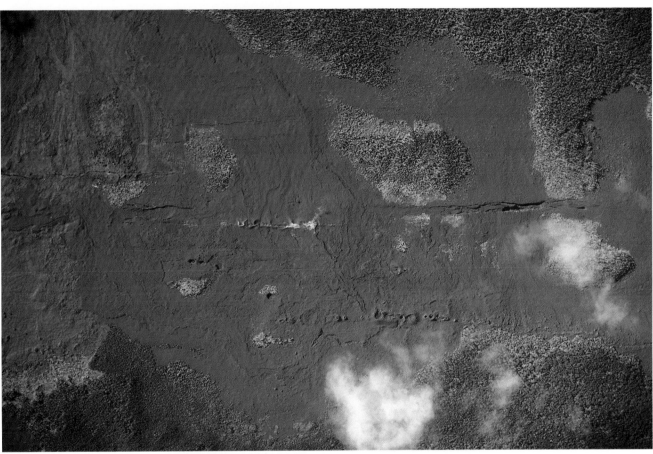

ABOVE
Eruptions of Hawaiian shield volcanoes frequent rift zones that radiate from the summit. Cracks and fissures, clear evidence of former eruptions, are easily seen from above. Sections of rift zone are kept barren of life because of frequent eruptions.

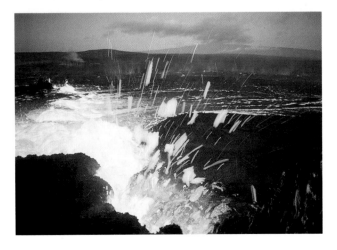

LEFT
Fissure eruptions drown in lakes of their own creation, as lava rises to the surface faster than it can flow away from the vent.

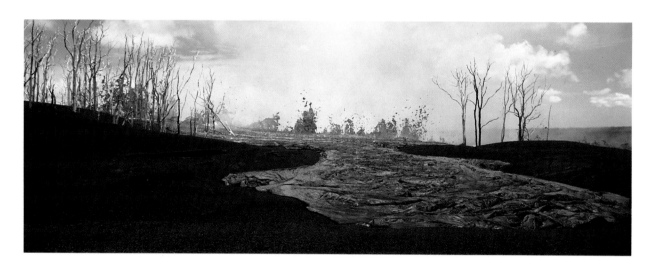

ABOVE

A fissure eruption begins as
the rift zone is ripped open for
several kilometers. Low
fountains rise and merge
along its length.

RIGHT

Falling lava forms a wall of
congealing spatter along an
erupting fissure. Such evidence
of former eruptions are
common along the rift zones
of a shield volcano.

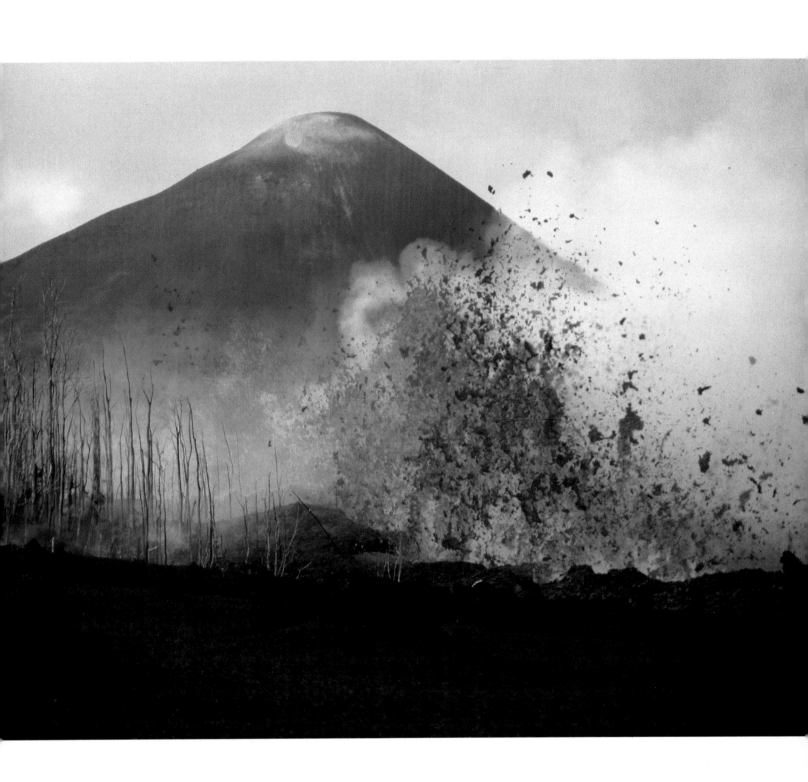

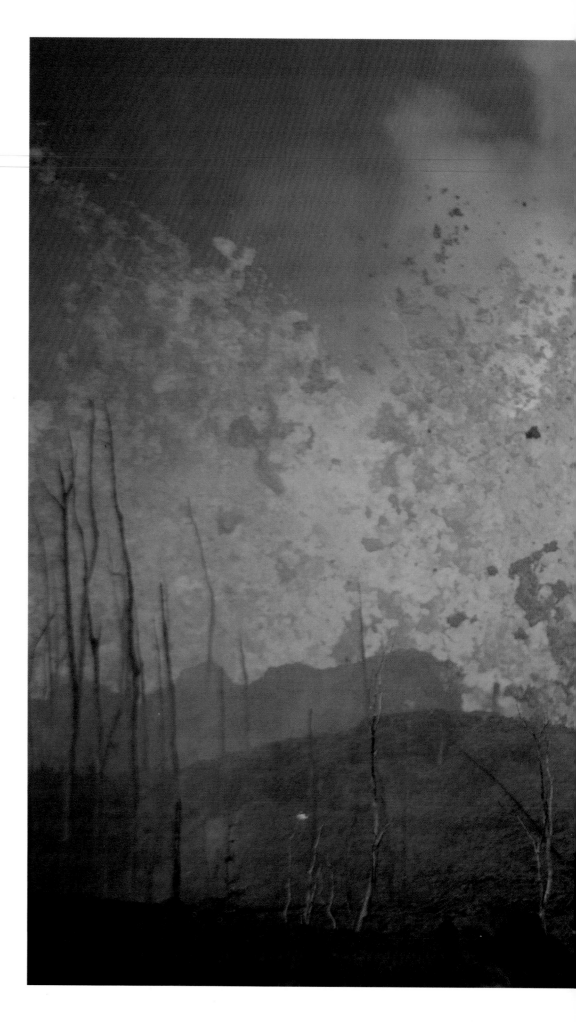

RIGHT

*Water dissolved in magma
expands rapidly as it nears the
Earth's surface, spraying
fountains of molten rock into
the air. As it emerges from the
fissure, erupting lava expands to
a light, incandescent froth.*

BELOW
By night the fountains of a
fissure eruption play behind a
black filigree of trees.

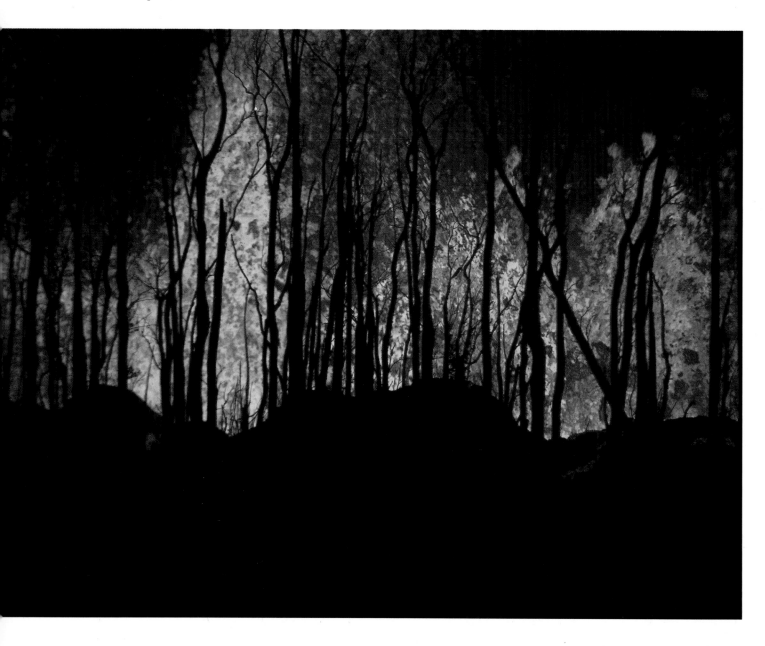

From close by, degassing lava issues quietly from a circular vent
20 meters wide, falling back on itself much like water bubbling
from a water fountain. Such activity can last for hours before a
fire fountain slowly rises to its full height of hundreds of meters.

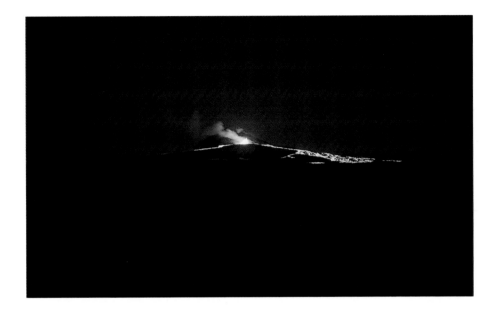

LEFT

As a fissure eruption wanes, the long, linear vent is sealed with congealed lava until only a single, narrow conduit remains. During subsequent eruptions all of the force is concentrated at this single, narrow vent. The beginning of an episode of high fountaining starts modestly as degassed lava remaining in the conduit from the previous episode quietly bubbles forth.

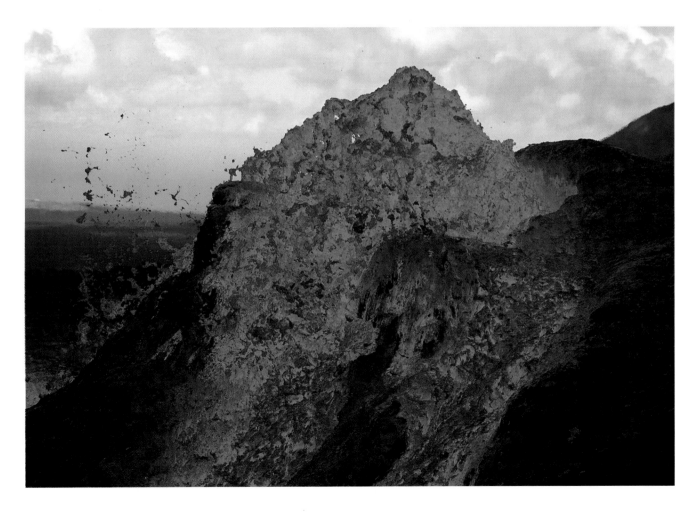

RIGHT
As fresh, gas-rich magma
rises in the eruptive
conduit, bubbles form and
expand throughout its
length. The resulting
increase in volume creates
tremendous pressure so
that a dome fountain
rises above the vent.
Water vapor escaping
from the rising magma
forms a white plume
above the vent.

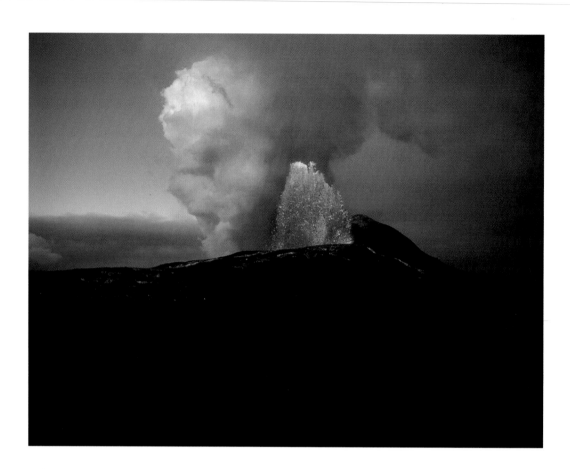

RIGHT
At its zenith, high fountaining sprays lava
hundreds of meters into the air. A
shimmering sheet of cooling, black shards
forms a growing cone at its base.

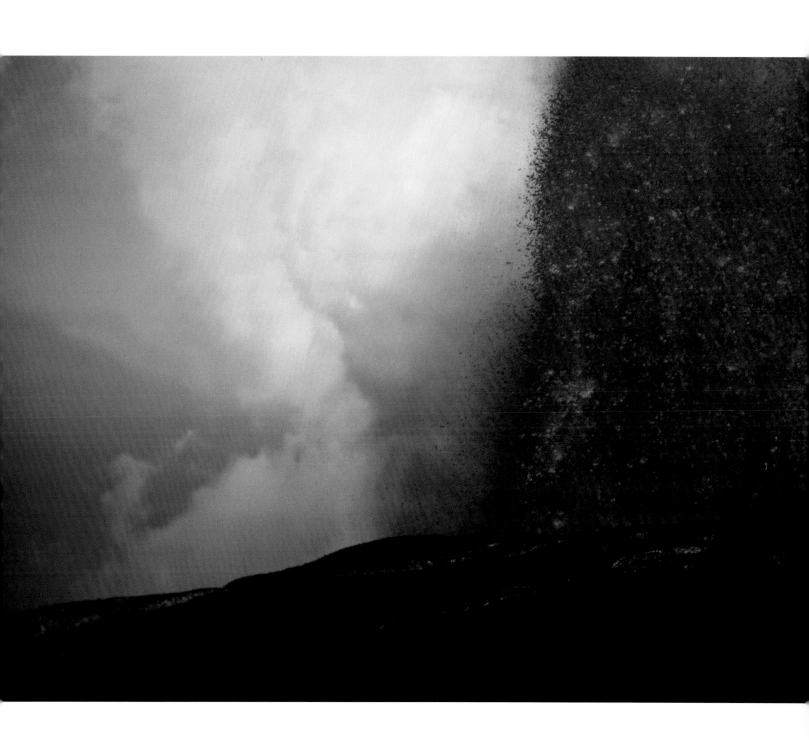

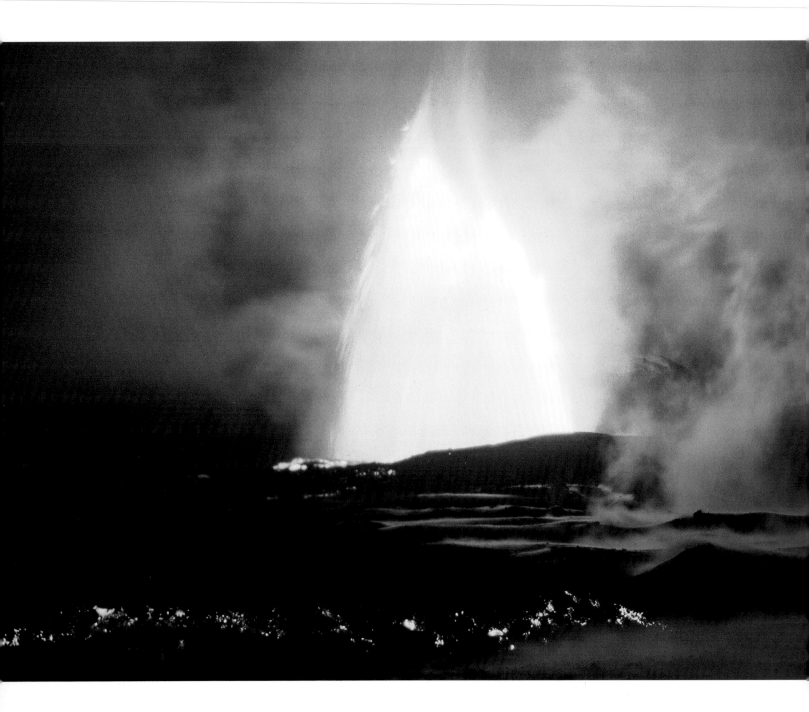

At night a one-second exposure
reveals an x-ray image of
the internal structure of
a fire fountain.

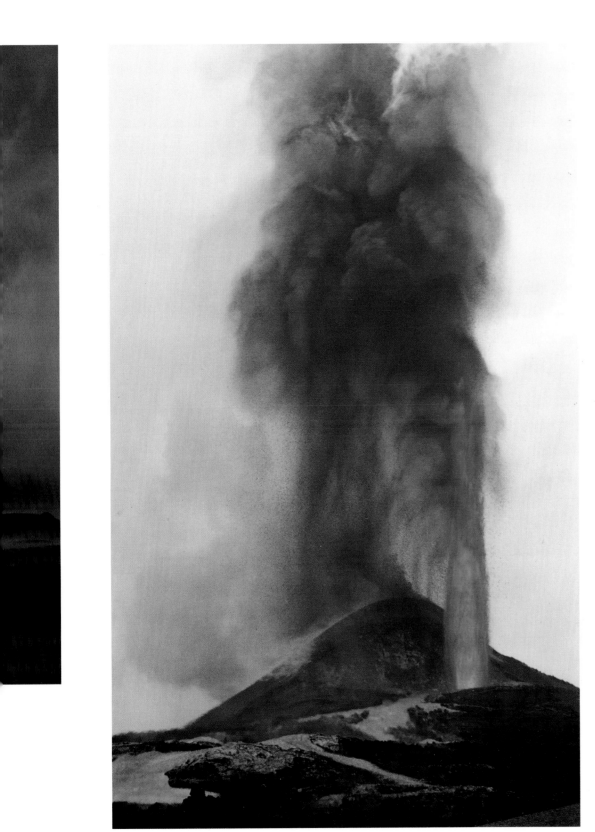

Pockets of gas trapped
deep in the volcano can
make their way into the
eruptive conduit where
they are vented to the air
under extreme pressure.
Fire fountains attain their
greatest height when this
occurs. The flows that
form as the still molten
rock falls back to the
ground have a mottled,
clinkery surface known
as a'a.

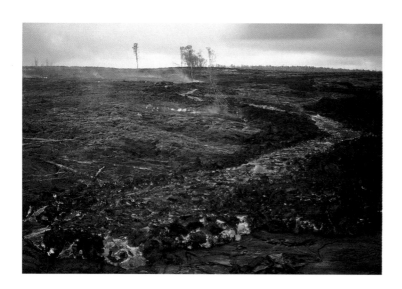

The advancing front of an a'a
flow spreads into a broad fan.
As an a'a flow advances, blocks
of rubble crumble from its sides
revealing a thick, glowing core.

Fissure eruptions and fire
fountains produce massive
a'a flows which enter the
forest and drown the trees
in a sea of fire.

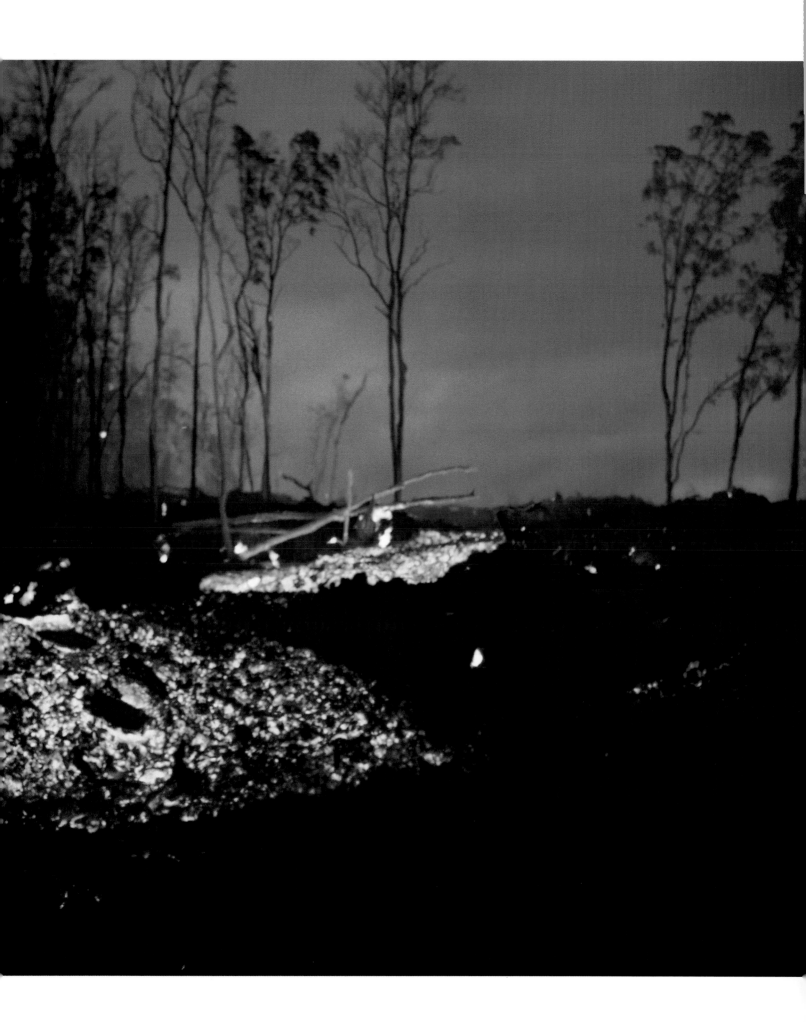

Chapter 5

The Ring of Fire

Chapter 5

The Ring of Fire

The most notable aspect of stratovolcanoes is the incredible variety in their eruptive styles. Much of the lava erupted to form stratovolcanoes is remelted sea floor sediment, including microscopic animal skeletons, river mud, and sand. In a few million years products of human civilization, sunken wrecks, beer bottles, pop-tops, and perhaps a few Spanish coins will undoubtedly be carried down to melt and become part of the andesitic magma that rises to form strato-volcanoes. Such times are short on a planet that has been evolving for over four billion years. To complicate things further, water is carried down with the sediment. With increased water content, the resulting magma becomes more explosive. This, together with the fact that the magma feeding stratovolcanoes is generally much less fluid than shield-building magma, is the primary reason they are much more dangerous than their basaltic cousins. As magma rises towards the surface, it melts and mixes with variable amounts of differing crustal rock, resulting in the eventual eruption of a wide variety of lava types. All of this stands in stark contrast with basaltic shield systems that have a common source rock type. In addition, basaltic magma rises through the lithosphere, which itself is made of a kind of basalt and differs little from one part of the ocean to another. All of this variation goes to support Jaggar's notion that shield volcanoes make a much more suitable laboratory for understanding volcanoes.

Because of the great variation in stratovolcanoes, it is not possible to describe a "typical" eruption. Yet, stratovolcanoes have many common features that can serve as a basis for understanding such systems. The name "stratovolcano" comes from a common internal structure consisting of alternating layers, or strata, of ash and more solid flows. Because tremendous amounts of ash are deposited on the upper slopes of stratovolcanoes, such volcanoes remain highly dangerous for years after an eruption ends. Heavy rains and

tropical storms can mobilize tons of ash to form surging rivers of mud, which can bury anything in their path. These mud flows, known as lahars, can approach the temperature of boiling water and represent one of the persistent hazards on stratovolcanoes. Thick layers of ash also make the structure of stratovolcanoes unstable and subject to landslides—a fact that also accounts for their often beautiful, conical form. Paintings of Mt. Fuji in Japan and Mount St. Helens before its explosive eruption are excellent examples of this aspect.

There are four radically different styles of eruption associated with the growth of stratovolcanoes. These are, in order of increasing explosivity, Strombolian, Vulcanian, Pelean, and Plinian. Not only do various stratovolcanoes vary in preferred eruptive style, but a stratovolcano can alternate from one to another over short time intervals during its development. Even a single eruption can shift from one form to another as it progresses, generally becoming increasingly less explosive.

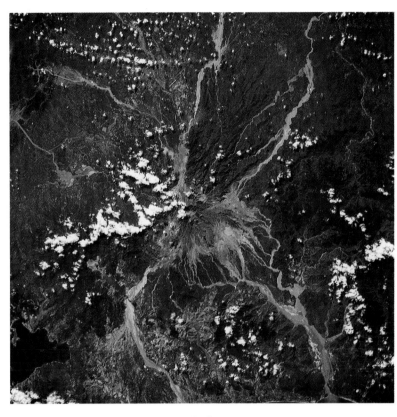

ABOVE
From space, Pinatubo Volcano in the Philippines appears as a giant spider embracing the land as rivers of mud radiate in all directions from its ash-laden slopes. Volcanic ash mobilized by tropical monsoons is one of the most serious long-term hazards following a major eruption of a stratovolcano.
COURTESY NASA.

Strombolian eruptions, named for the volcano Stromboli in Italy, most resemble eruptions of shield volcanoes, producing more surface lava flows than the others. Still, the lava erupted is much less fluid and more gas-charged than molten basalt and tends to erupt in a series of sharp blasts, like a volley of cannon fire. With each blast, fragments of cooling lava produce a spectacular burst like a fireworks display. Strombolian eruptions are also the least hazardous of the four, increasing the mass of a volcano by adding alternating layers of ash and lava to its surface. The resulting structure is somewhat more durable than that resulting from the other eruption styles.

Eruptions of the Vulcanian type eject a much less fluid lava, typically forming cauliflower-shaped clouds of fine ash as fresh magma explodes more or less continuously like solid rocket fuel. Early in a Vulcanian eruption, the cloud is dark and charged with lightning, later bleaching to white as solid ash separates and settles out. Blocks of solidified new lava ejected during Vulcanian eruptions have a sharp, angular shape when compared with the more glassy, fluid ejecta from Strombolian eruptions. Lava flows during Vulcanian eruptions are short and thick and rarely travel more than a few hundred meters from

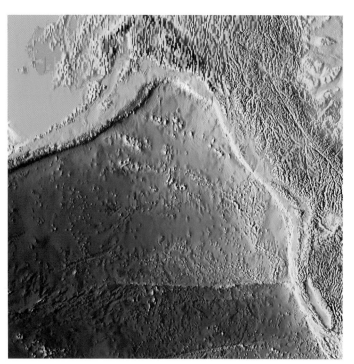

the vent. Consequently, unconsolidated ash is the primary new material added to a volcano's surface. For volcanoes where this style dominates, a weak cone consisting of layers of ash and cinder results.

Pelean eruptions are named after the eruption of Mt. Pelee in 1902 that destroyed the town of St. Pierre on the island of Martinique. As in Vulcanian eruptions, ejected blocks of new lava are angular and block-like. The main distinguishing feature of Pelean eruptions is the formation of a summit dome. These are hemispherical, rubbly piles of very thick, sticky lava that ooze from the eruptive vent after gas-rich lava has been expelled. Typically, the collapse of the summit dome produces the terrifying, glowing avalanches known as *nuées ardentes* (NU´-AY AR-DENTS´). It was one of these that leveled the town of St. Pierre in 1902. Although domes are somewhat less explosive than earlier erupted lava, they are still extremely dangerous. During the 1950 eruption of Hibokhibok Volcano in the Philippines, for example, a fragment of a dome brought down in one such avalanche lay quietly for over an hour before suddenly exploding so violently that shards of lava were imbedded in nearby coconut trees. The occurrence of glowing avalanches is usually sufficient for an eruption phase to be classified as Pelean.

The emplacement of a summit dome is a significant way in which many stratovolcanoes grow. A large dome can continue to expand slowly for several years, adding hundreds of meters to a volcano's height, and replacing much of the material blasted into the atmosphere during the explosive onset of an eruption. The glowing avalanches, spawned as parts of a dome fall away, rush down the slopes of a stratovolcano at speeds exceeding 100 kilometers per hour. They cannot be outrun. When they finally come to rest, the incandescent ash welds itself into a tough, durable layer that resists erosion and gives a stratovolcano much of its limited strength. These avalanches also play the important role of distributing material to the lower flanks, contributing to a stratovolcano's steep, conical form.

Plinian eruptions, the fourth type, are by far the most explosive. They are named after the elder Pliny, whose nephew described so eloquently the destruction of Pompeii by the Plinian eruption of Vesuvius Volcano in AD 79. Plinian eruptions produce great volumes of new lava, generally as pumice, a light, fluffy form caused by extreme degassing and expansion of lava as it erupts. Pompeii was literally buried beneath tens of meters of this material. As a Plinian eruption progresses, the magma chamber feeding it

becomes deeply cored, and large parts of the volcano collapse into the void thus created. Plinian eruptions spread thick blankets of ash and pumice for thousands of square kilometers downwind. The initial eruption of Mount St. Helens was of the Plinian type, although later episodes were considered Pelean. The well-known eruption of Krakatau Volcano in 1883 and the eruption of Thera that ended the Minoan civilization around 2,600 BC are also considered to be Plinian.

There is yet another kind of eruption whose style is shared by both shield volcanoes and stratovolcanoes. This type, known as Ultravulcanian, occurs when a large amount of water is drawn into a partially emptied magma chamber. Sometimes such eruptions occur at the beginning of Vulcanian and Strombolian eruptions as debris choking the eruptive vent is cleared out of the way violently. More frequently, they occur in the latter stages of Plinian eruptions as the void formed by the coring of the deep magma chamber is filled with whatever material is available. If the material is water, a tremendous steam explosion

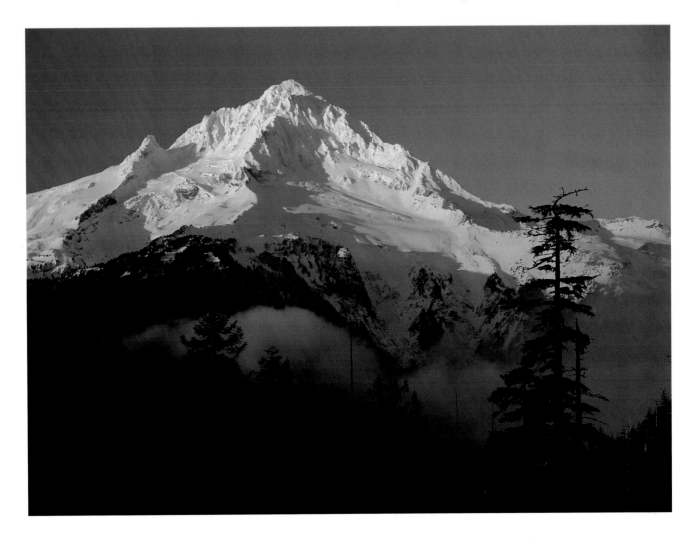

The eruption of a stratovolcano often begins with an eruption column as thick, explosive lava injects fine ash into Earth's upper atmosphere at velocities approaching the speed of sound. The collapse of a column as the eruption wanes produces hurricane force winds at its base. PHOTOGRAPH BY ROGER WERTH.

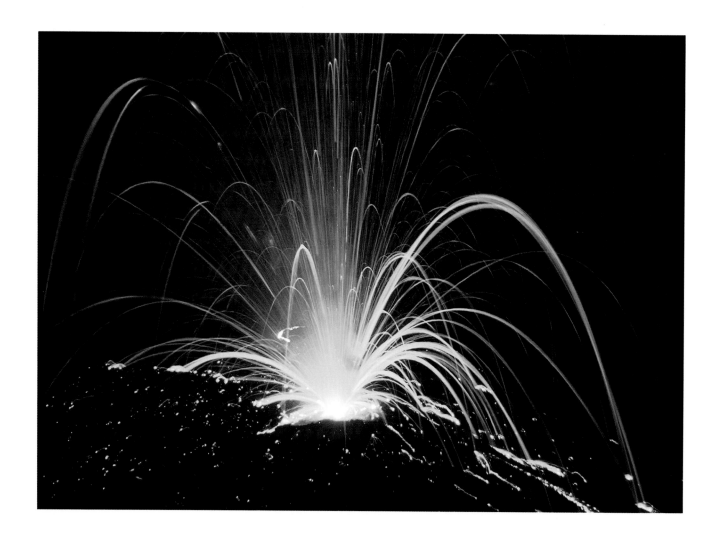

ABOVE
Lava from stratovolcanoes often behaves explosively when it reaches the surface of the earth. Here Strombolian fireworks illluminate the summit of Akita-Komagatake Volcano in Japan in September of 1970, as thick lava explodes into showers of glowing fragments that arch through the air. PHOTOGRAPH BY DAISUKE SHIMOZURU.

results. Characteristically, only fragments of old lava, fractured and broken by explosions more powerful than an atomic bomb, are ejected. One of the best-known Ultravulcanian eruptions is the 1924 eruption of Kilauea Volcano on Hawaii. As magma drained from the summit magma chamber, water rushed in, and the resulting steam explosion showered the summit area with angular blocks of old lava and produced an immense column of ash and steam. This eruption marked a dramatic change in the behavior of Kilauea Volcano. Previous activity had been confined to the summit, and a lava lake had persisted there for more than a century. Subsequently, after several decades of quiescence, most of the activity shifted to the rift zones, producing sustained eruptions and rivers of fire that have been systematically resurfacing the flanks of Kilauea ever since.

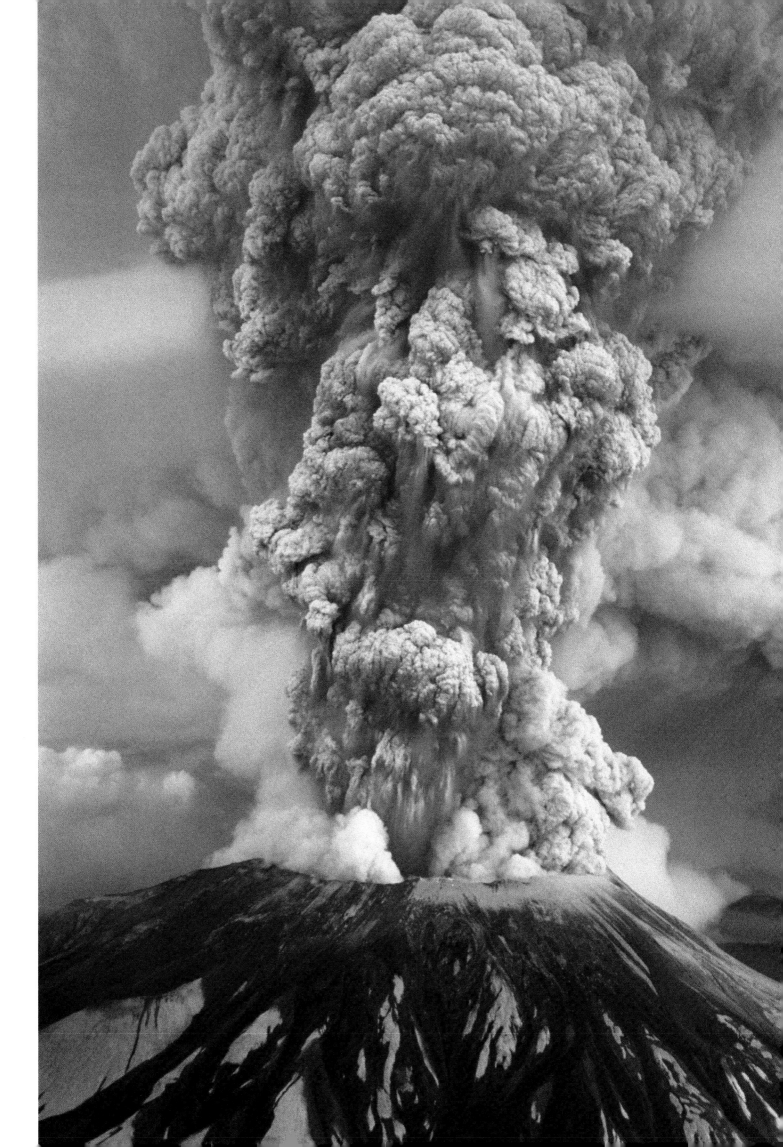

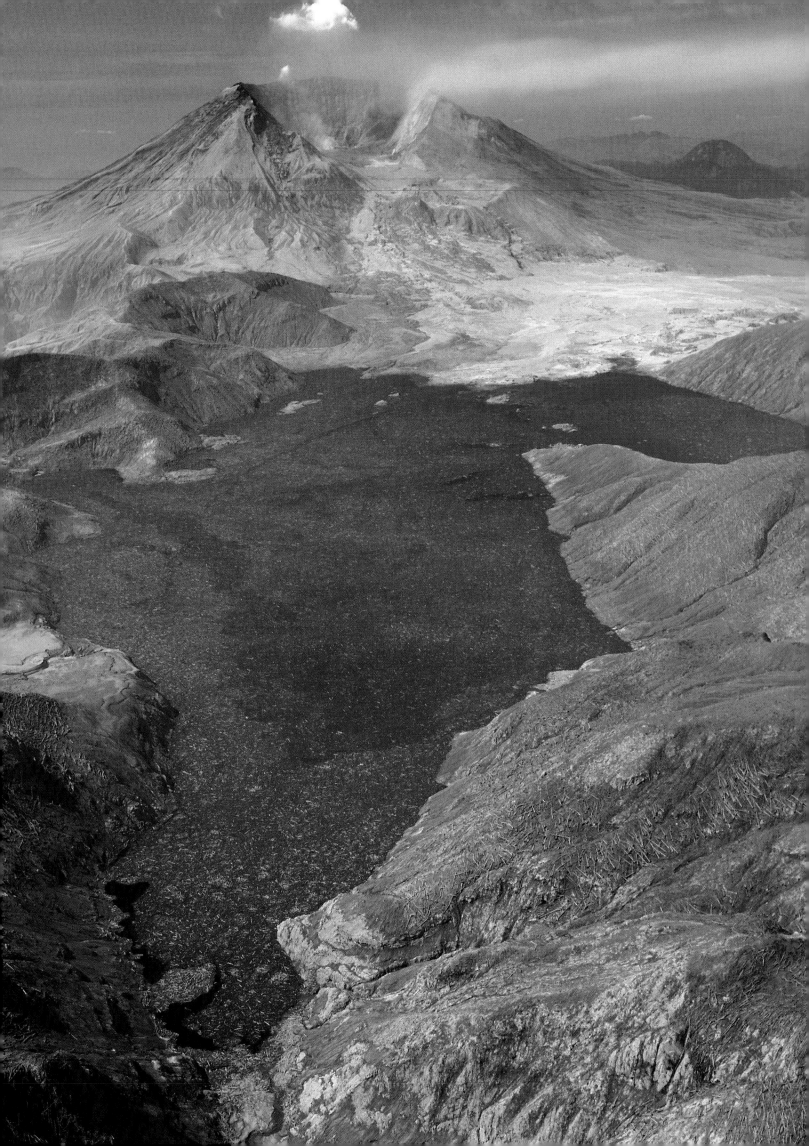

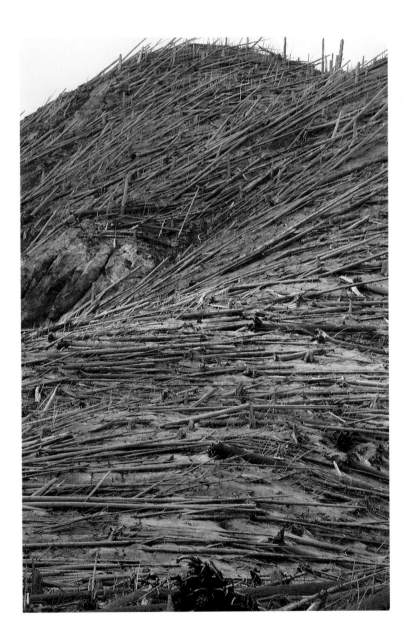

One day following the extrusion of a summit lava dome on Unzen Volcano in 1992, deep cracks formed which split it into four parts. Such chunks break off and fragment into treacherous glowing avalanches known as nuées ardentes. They are called glowing avalanches, because at night they radiate a ruddy, red glow as a result of internal temperatures that can be as high as 800° C. PHOTOGRAPH BY TSUTOMU ISHIZU, COURTESY MAINICHI SHINBUN.

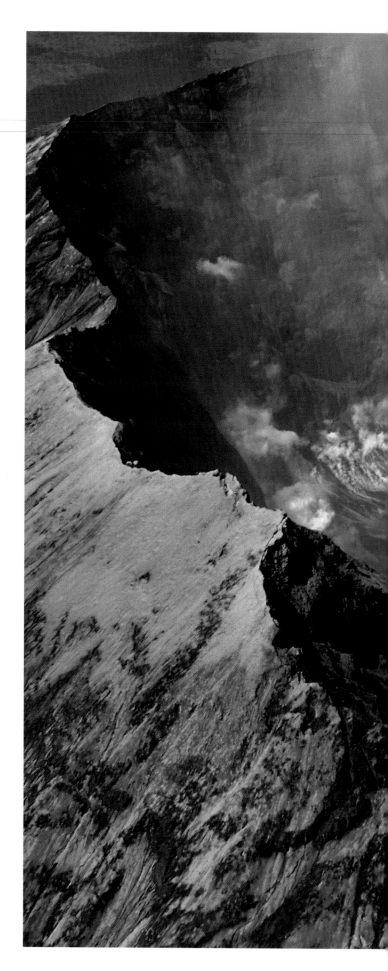

RIGHT

Lava domes hundreds of meters across grow as thick lava oozes from the conduit following the violent phase of an eruption. Such a dome began growing about one month following the main blast during the eruption of Mount St. Helens. Lava reaching the surface during the first month of eruptive activity was too gas-charged and explosive to form a stable dome. PHOTOGRAPH ROGER WERTH.

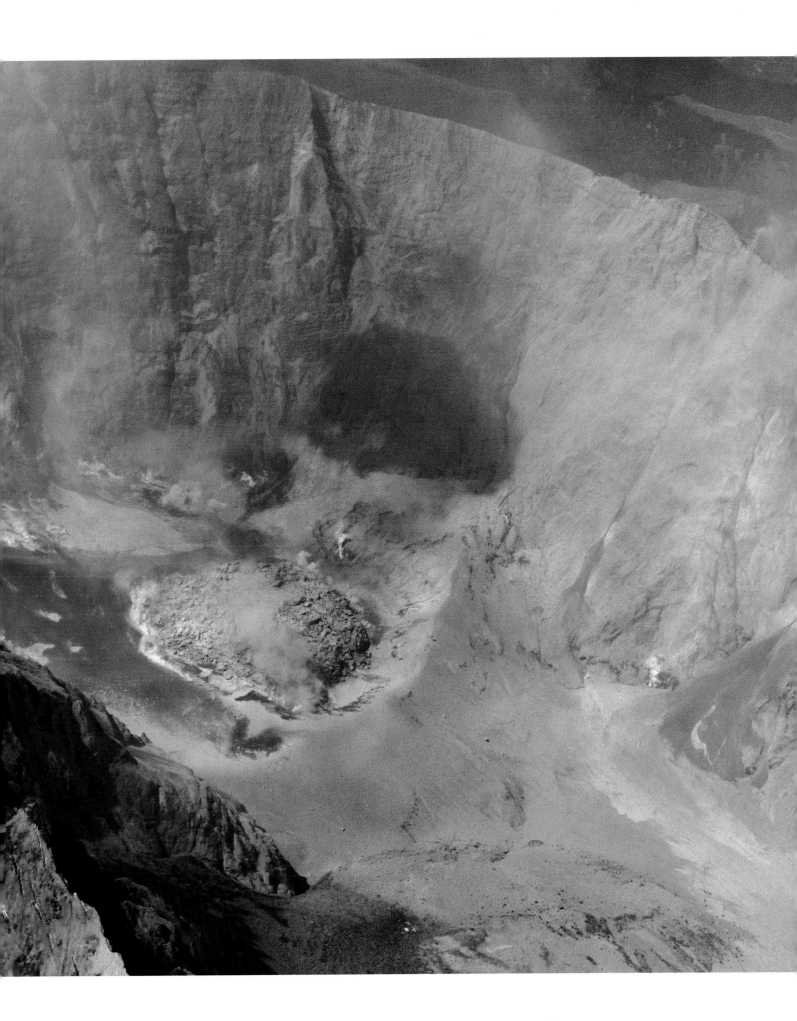

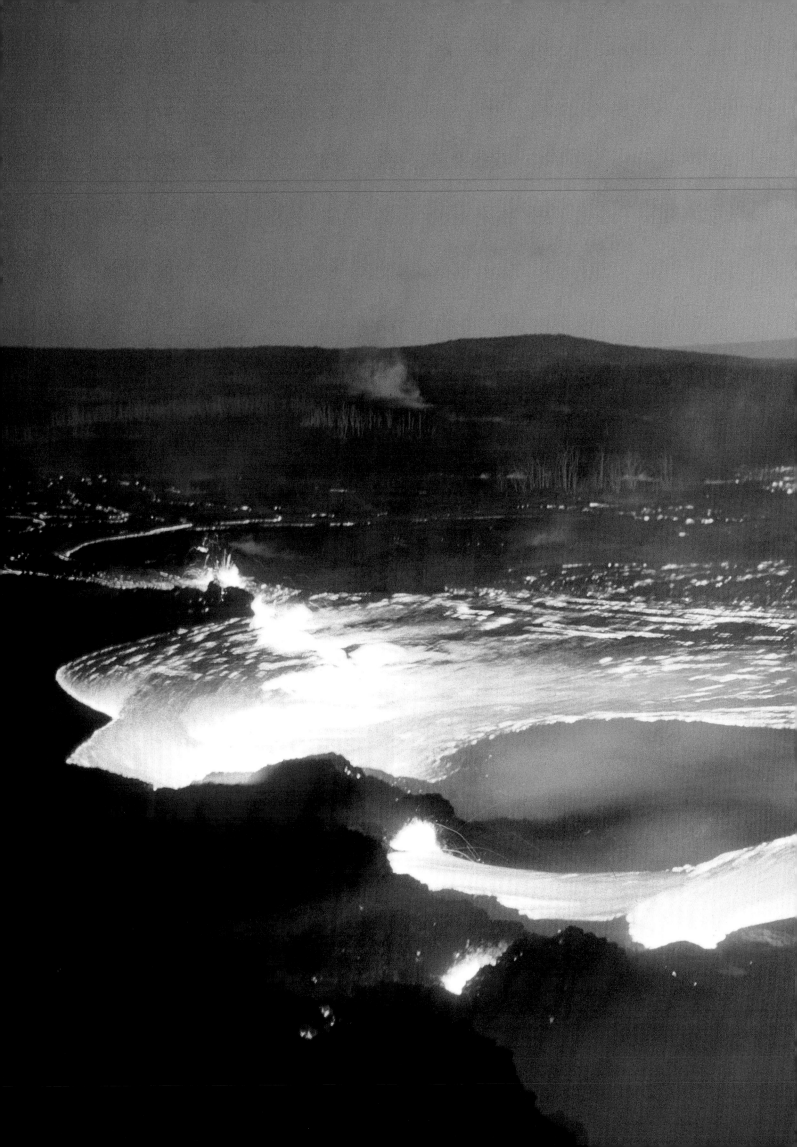

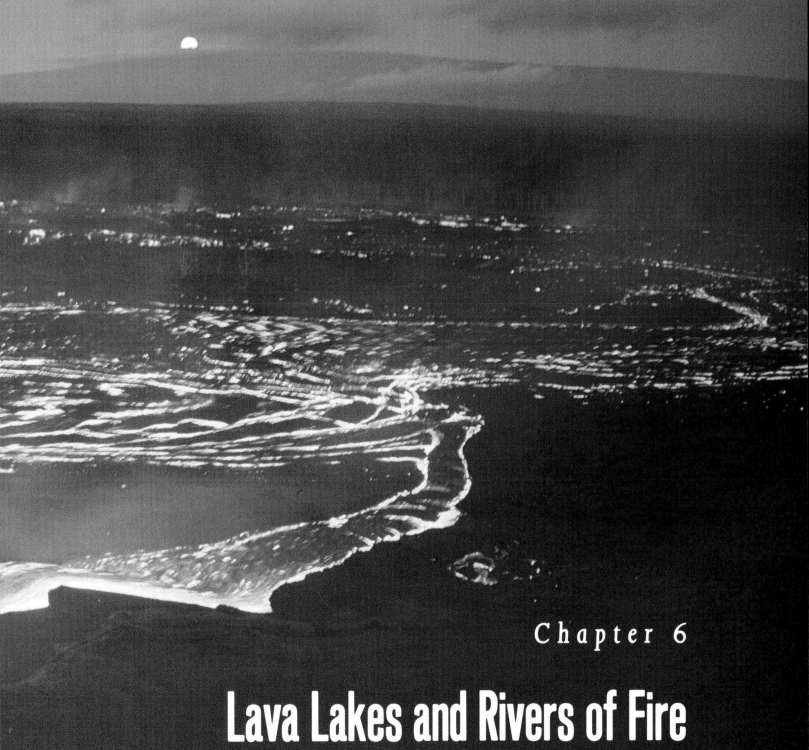

Chapter 6

Lava Lakes and Rivers of Fire

Chapter 6

Lava Lakes and Rivers of Fire

Following a major eruption, there may be an extended period of continuous activity lasting for years, decades, or centuries. Sustained eruptions of shield volcanoes produce the greatest amount of growth and control the overall shape of the volcanoes. Lava lakes are a necessary part of this process. Although the most violent activity generally occurs at the onset of an eruption, it adds only a comparatively small amount of material.

Before its disappearance during the Ultravulcanian eruption of 1924, a lava lake seemed to be a permanent feature of the summit of Kilauea Volcano. William Ellis, visiting the summit of Kilauea in 1823, provided the first written description of the phenomenon when he penned:

> The fires of Kilauea, darting their fierce light athwart the midnight gloom, unfolded a sight terrible and sublime beyond all we had yet seen. The agitated mass of liquid lava, like a flood of melted metal, raged with tumultuous whirl.

Little had changed by 1868 when it was described by Mark Twain in the lead quotation for this chapter. For more than a century, these and many others were awed by the majestic pool of molten rock that resided at Kilauea's summit.

The long-lasting lava lake at Kilauea's summit followed the severe Ultravulcanian eruption of 1790. This eruption, similar to the 1924 event but much more violent, destroyed all of the vegetation within a few kilometers of Kilauea's summit and covered its downwind side with volcanic ash up to depths exceeding 10 meters. Several dozen Hawaiian warriors were killed by base surges, similar to the glowing avalanches produced by stratovolcanoes. Fortunately, these eruptions are infrequent. The volcano maintains a record of such events as thick layers of ash are sandwiched between layers of lava that took

thousands of years to accumulate. Much of the material that was removed during the 1790 eruption was replaced, as overflows from the long-lasting summit lava lake added new lava hundreds of meters thick to the floor of the summit caldera. The less violent eruption of 1924 terminated caldera filling, and most subsequent eruptions have occurred along Kilauea's two rift zones. Fortunately for those trying to learn more about volcanoes, lava lakes are common features of sustained rift zone eruptions as well.

A lava lake is a deep, undulating pool of molten rock that develops when the vent geometry is such that the pressures required for "curtains of fire" and "fire fountains" can no longer be attained. With the formation of a lava lake, the output of lava becomes steady and continuous. Ponderous waves roll slowly across the surface, cracking it to reveal the red lava within. To some, the specter is a window into the heart of the Earth, reminding us of an earlier time when oceans of liquid rock lapped the shores of the first continents. Cooled by the air, its surface becomes a flexible skin of plastic rock, torn and crumpled

BELOW
The eruptions of shield volcanoes are not always safe. Visitors to Kilauea Volcano in 1924 observed a giant, turbulent column of ash, steam, and rocks erupting from the summit when water invaded the summit magma chamber. Eruptions like this one, and a similar but more violent one in 1790, can be more devastating than the explosive eruptions of stratovolcanoes. PHOTOGRAPH BY TAI SING LOO, COURTESY BISHOP MUSEUM.

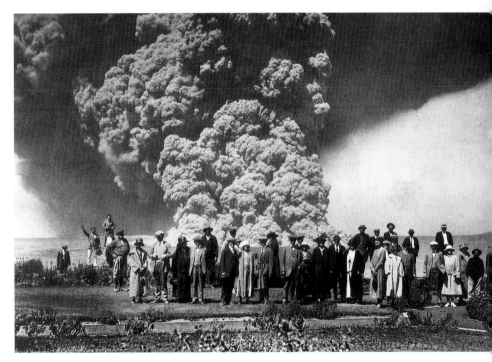

by the currents below, much as the plates of the Earth are driven and cracked by similar unseen forces. Here, too, we see the rifts, wrinkles, and tears like those that move the continents and shake our cities with the thunder of earthquakes. The surface of an active lava lake rises and falls, responding to subtle changes in pressure deep within the volcano. Unfortunately, the compelling beauty of a lava lake sometimes has an ominous side. The episodic nature of the fire fountains gives way to a continuous, less voluminous out-pouring of lava that can be sustained for years. Slowly, over weeks and months, these flows construct the thermally insulated tubes that can carry lava many tens of kilometers away from the site of an eruption.

The lava most often flowing from lava lakes is called pahoehoe (PA-HOY-HOY) and is much different from the a'a lava produced by "curtains" and "fountains." Pahoehoe flows are smooth and sinuous, with liquidlike surface textures ranging from ropy or braided to huge, lapping folds like the skin of an elephant. The flows that cool to form pahoehoe are much more fluid than those forming a'a, which tend to be hotter and more gas rich. Closest to the vent where the most gas-rich lava is found, a form called shelly pahoehoe looks almost frothy. Pahoehoe lava is transported in rapidly moving rivers.

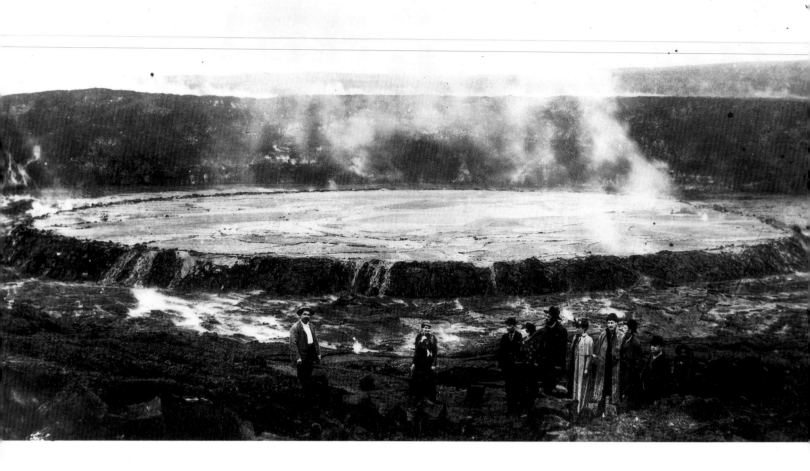

Because pahoehoe lava is so fluid, it forms cataracts and standing waves similar to water rushing down a steep mountain stream. At the downstream end of a lava river, wide flows advance over a broad front. As pahoehoe cools, it forms a thin, leathery skin which is stretched and turned under as the flow advances.

Left exposed, a river of molten rock rapidly loses heat and begins to solidify. Starting at the edges, a thin sheet of lava spreads over its surface like a river freezing inward from its shore. Slowly, the open channel remaining where the flow is fastest narrows and freezes over, enclosing the flow in a tube of solid rock. Encased in stone, flowing lava loses little heat. Because of this, pahoehoe lava covers most of the volcano's subaerial surface, while a'a still dominates near the vents. The surface above a lava tube bears scant evidence of the live, hot lava flowing through tubes within. Widely separated plumes of bluish-white gas, looking like smoky fires, mark its sinuous path down the volcano's flank. Weak spots in the roof collapse, forming skylights revealing rivers of lava streaming through caverns with glowing walls. By day, the view through a skylight offers a glimpse into the volcano's secret inner world. By night, light shines forth like a beacon that can be seen from ships far out to sea.

The flows on the gentler, lower slopes advance more slowly. Along a broad front, small buds of melted rock break out and chill into a form of pahoehoe known as lava toes. Tube-fed flow fields, especially along the coast, add more layers of rock to the volcano's

flank, covering everything—including the works of man—in the process. It has always been so, and the art and artifacts of the Hawaiian people are now intricately layered with flow after ancient flow. More recently, modern roads and towns have now been added to this legacy in stone.

The first streams of lava to reach the water's edge run down bare sea cliffs resembling drippings from a red candle. Driblets of molten rock dangling toward the sea are pulled by their own weight into taffylike ribbons before being engulfed by the endless succession of breaking waves. As the volume increases, the cliff is transformed into a mighty waterfall of fire, building new land faster than even the pounding surf can carry it away. Where a river of lava pours into the ocean, a massive white column of steam billows into the sky, flickering with an inner light as new land is forged at its base. Like hot glass thrown into cold water, most of the lava that reaches the sea is shattered into the sharp, angular fragments known as black sand. Moved and shifted by coastal currents, beaches of black sand develop in protected bays of a shore scalloped by ancient flows. Elsewhere along the shore, black sand beaches, lasting for only a few decades, reveal where older flows have reached the sea.

Here, too, lava tubes form and, despite the ravaging of the waves, manage to penetrate beneath the surface to continue growing under water. But the pounding of the waves upon the shore cannot be denied, and time and again the roof of the tube is broken open. Instantly, as cold sea water mixes with hot lava, steam roars from the new skylight. Rocks, ash, and glowing chunks of lava are lobbed into the surf, building piles of ash and cinder called littoral cones. For a while, the forces of creation prevail, and the power of the sea is held in check. New land stands above the waves. But no sooner does the lava cease to flow than the ocean begins again to gnaw away at the newly formed shore. It is not a battle between fire and the sea that is played out here. Rather, it is but a few steps in the slow dance of creation, preserving the balance of nature on a planet where the only constant is change.

BELOW
Slow currents in an active lava lake crumple and tear its surface, replicating in miniature the tectonic processes of the Earth. New crust appears shiny and metallic. Jagged, red lines of upwelling correspond to the oceanic rifts, and the depressed crust shows where two plates converge and one or both are drawn back into the maelstrom below.

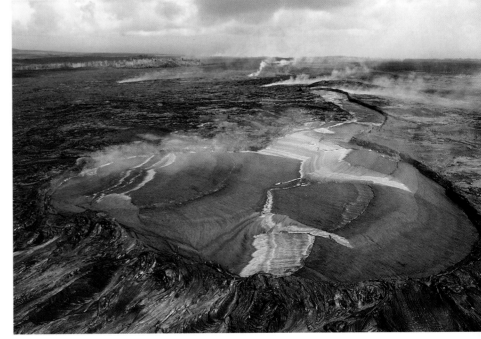

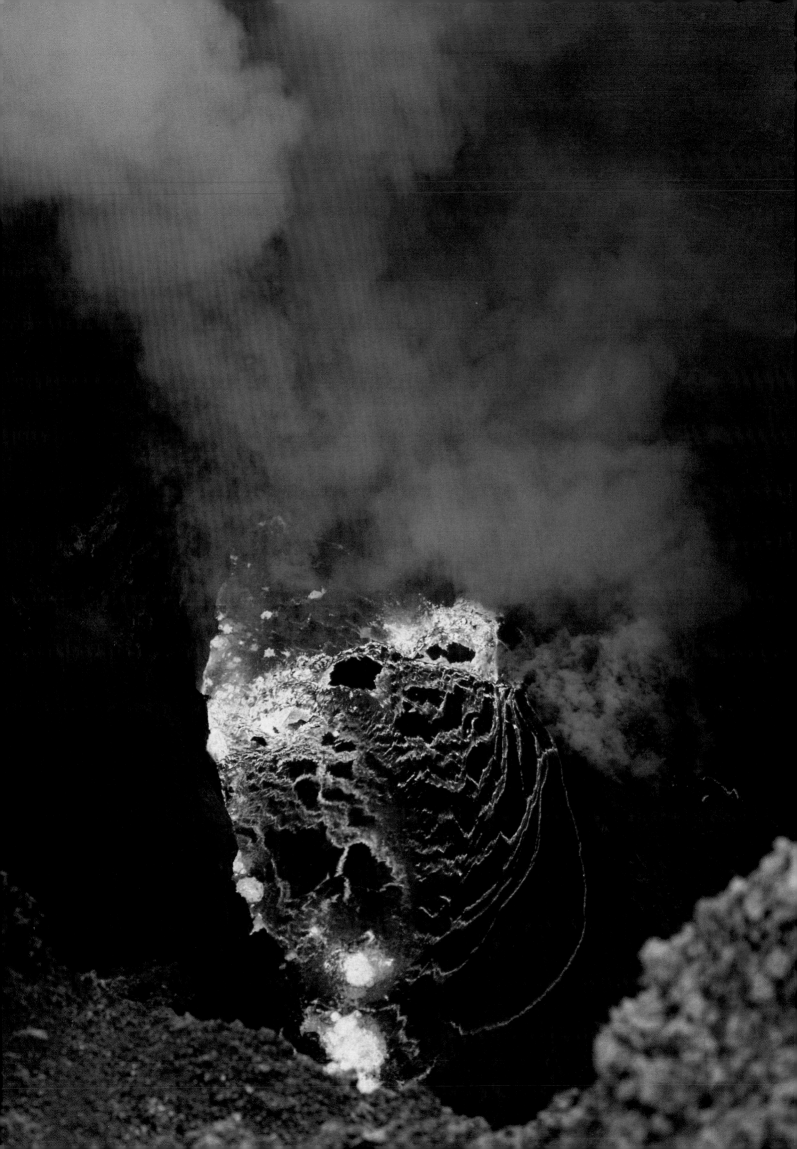

Some lava lakes are so active that no skin of rock can form at their surface so they appear as a seething cauldron of fire. Any skin that does manage to form is quickly ripped apart. Bubbles burst as gas wells up from below, stirring the molten rock and splashing the shores with blobs of cooling spatter.

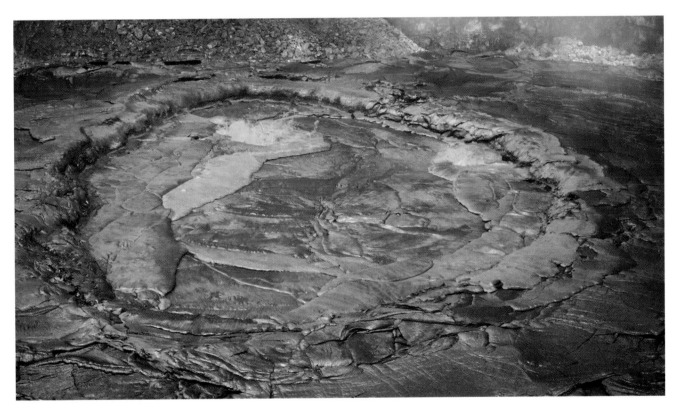

ABOVE
An active lava lake rises and falls, responding to pressure changes deep within the volcano. As it drops, the walls of the lake glow red briefly before they cool and darken.

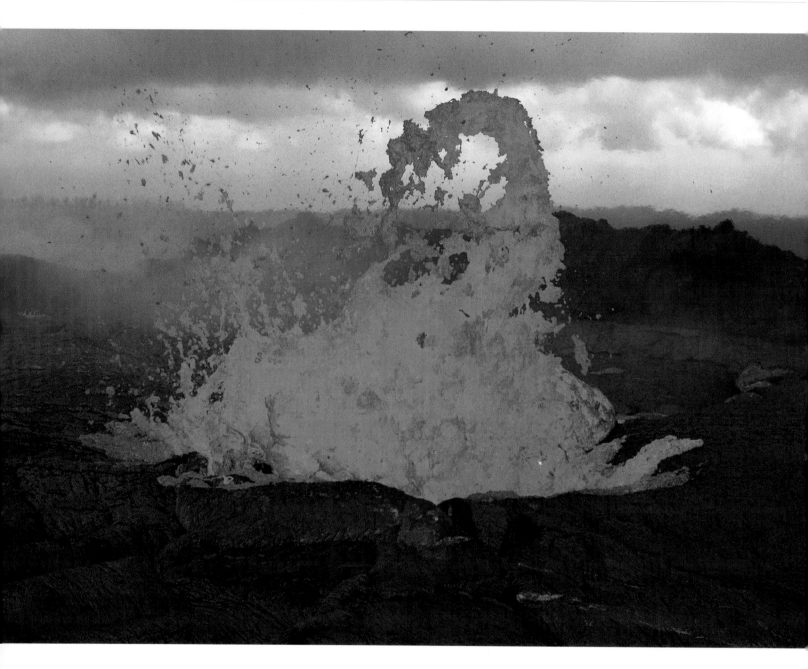

ABOVE
Domes of degassing lava assume
strange and unusual shapes
as they prowl the surface of
an active lava lake.

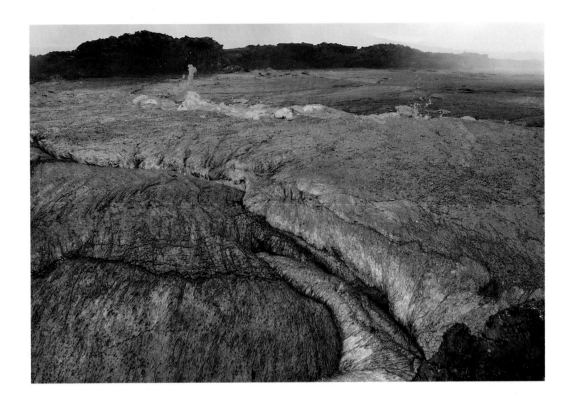

TOP

The rocky surface of a lava lake is made of light, gas-rich lava that is fragile and brittle after it cools. As a lava lake evolves, the crust is continually turned under and remelted.

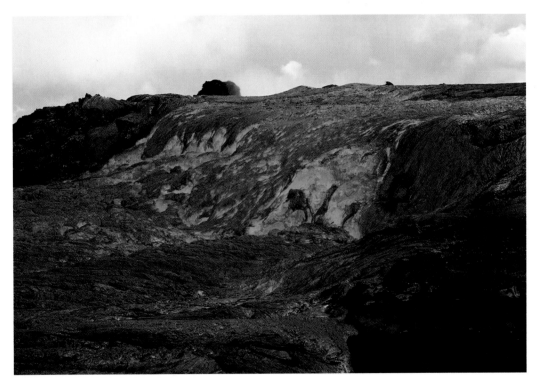

BOTTOM

As a lava lake rises and falls responding to subtle changes in pressure deep within, it occasionally overflows its bounding levees. An overflow can form a lava tube carrying hot lava for great distances. Standing waves, cataracts, and lava falls give the appearance of a rushing stream made of fire.

Lava lakes often produce a
smooth, fluid kind of lava flow
known as pahoehoe, markedly
different from the rough a'a
lava over which it flows.

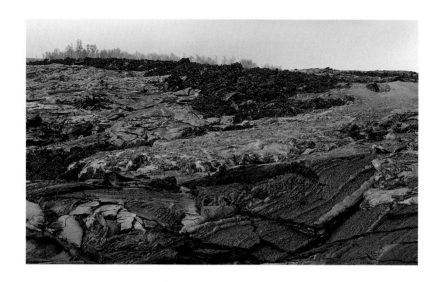

BOTTOM
As the surface of a broad flow
chills to stone, channels remain
that are kept open for a while
by the faster flow. A branch
hanging above a channel bursts
into flame from the heat
radiated from below.

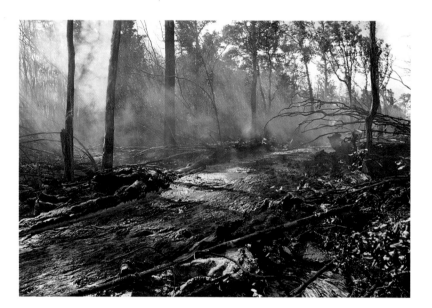

RIGHT
The green of the forest contrasts with the
deep red lava as a river of pahoehoe carves a
blackened corridor through the trees.

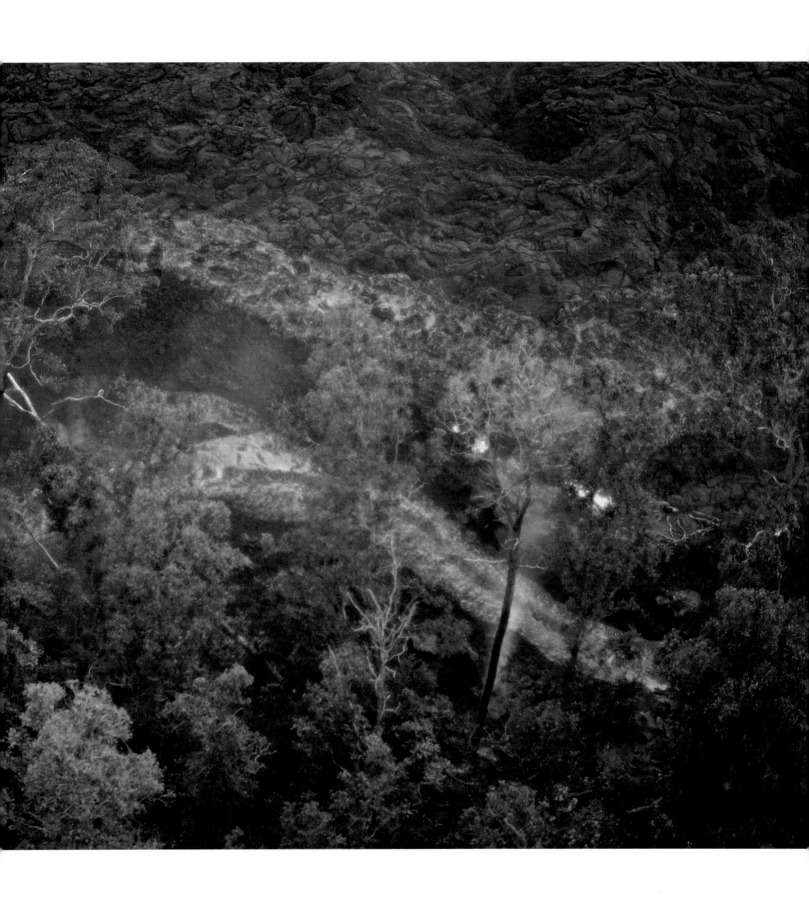

As the surface of a lava channel solidifies, a
thick roof of rock forms which insulates
the lava below so that it can travel for great
distances while losing little heat.

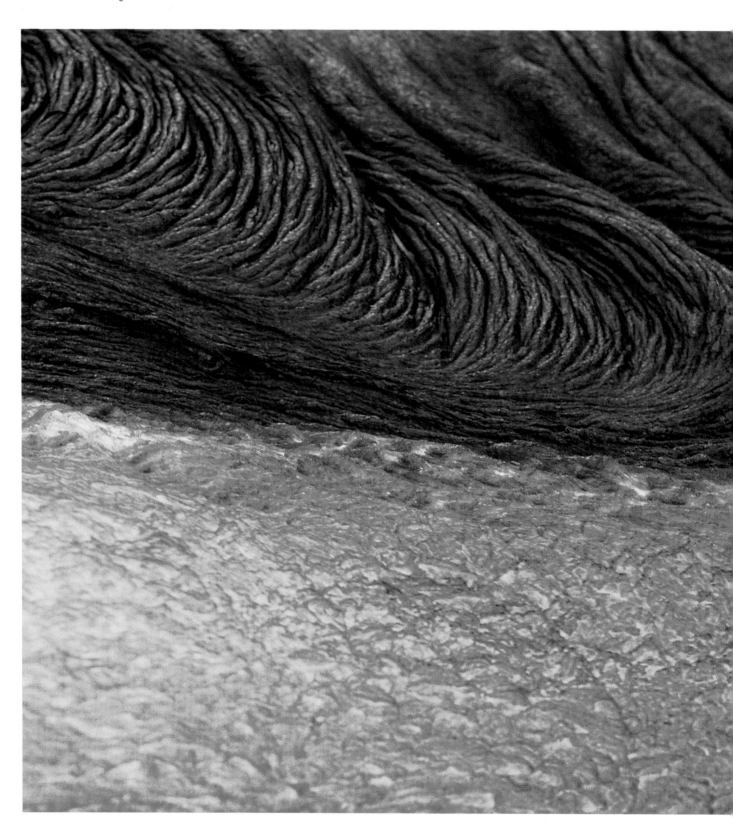

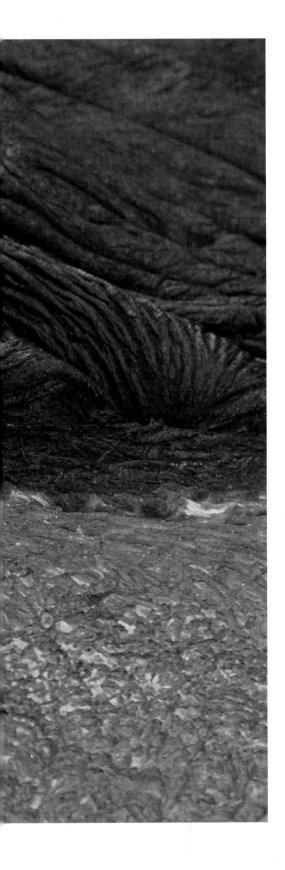

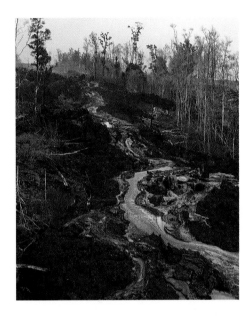

Because of the great temperature difference between molten rock and air, lava exposed to the atmosphere cannot flow very far before it begins to "freeze" to solid rock. Along its length a lava channel displays different stages of tube formation.

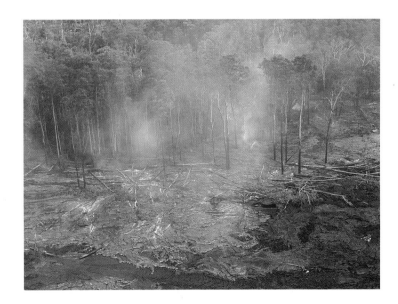

Sections of the roof of a young lava tube can collapse to form skylights. Through such occasional windows into the interior of a volcano, the rushing rivers of lava feeding distant flows can be observed.

RIGHT
Skylights formed in new flows have
thin, fragile roofs over raging
torrents of molten rock.

TOP
The inside of a lava tube is
heated to incandescence as
remelted lava forms rocky
"icicles" from its roof.

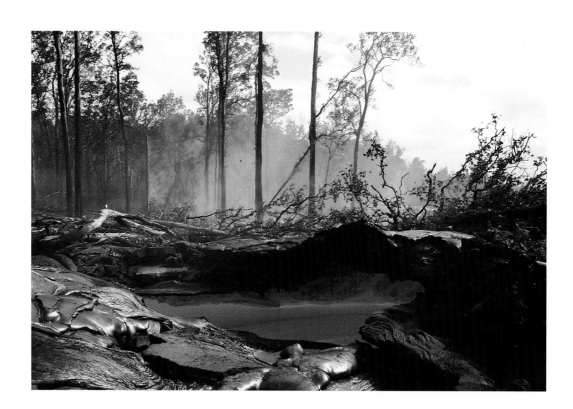

BOTTOM
Lava flows surround the
trunks of large trees,
freezing to pillars of stone
before the wood within
burns away, leaving a
toppled forest lying on the
cooling surface. As lava
drains away, such columns
can support a thick
slab of solid rock.

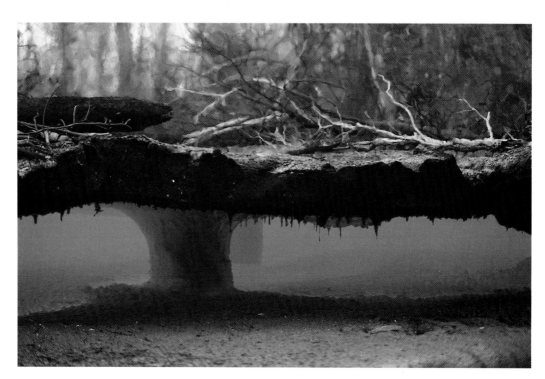

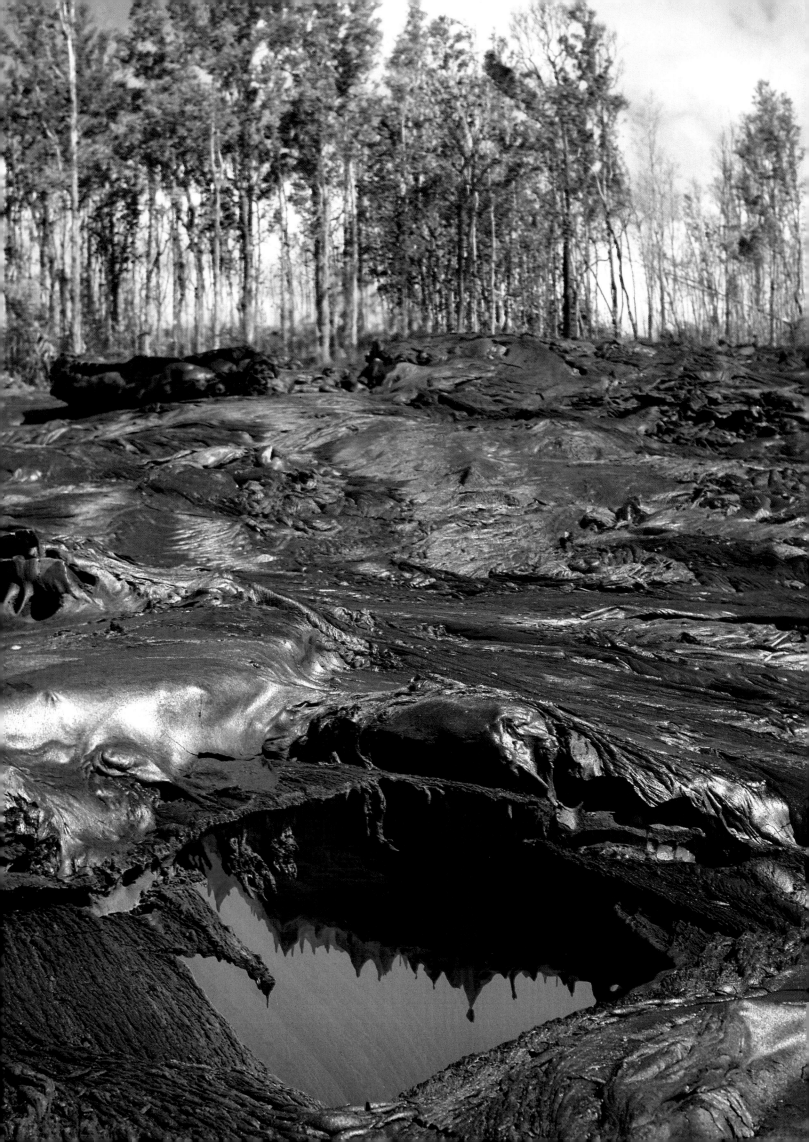

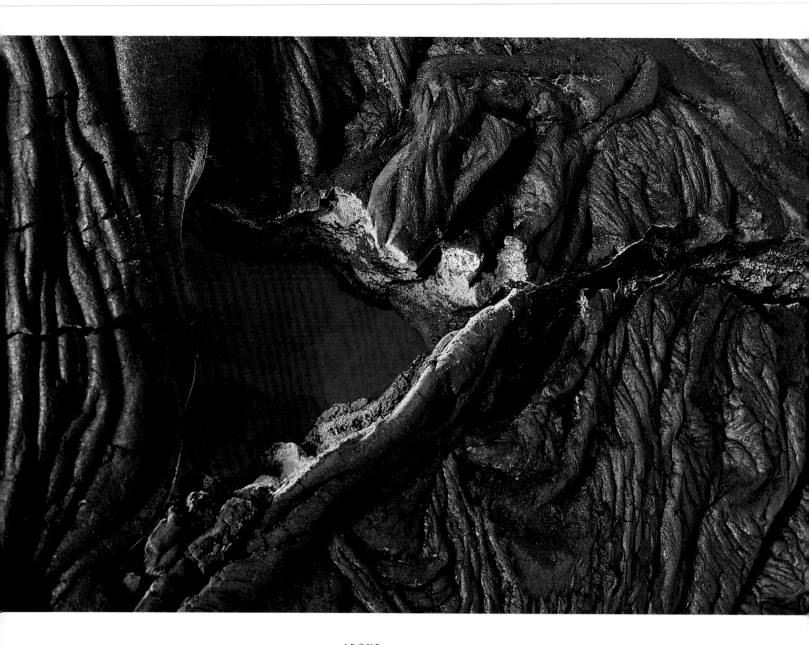

ABOVE
Long after the flow within has dwindled,
super-heated gases rushing through a lava tube heat
the interior to incandescence. Sulfurous vapors
escaping through skylights leave a rime of crystalline
sulfur deposited around the rim.

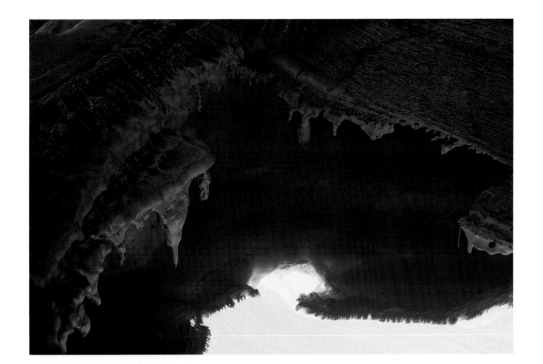

TOP
In mature tubes, large stalactites of lava form from rock melted from its roof by hot gases. Such tubes can remain active for years, feeding flows on distant slopes of the volcano.

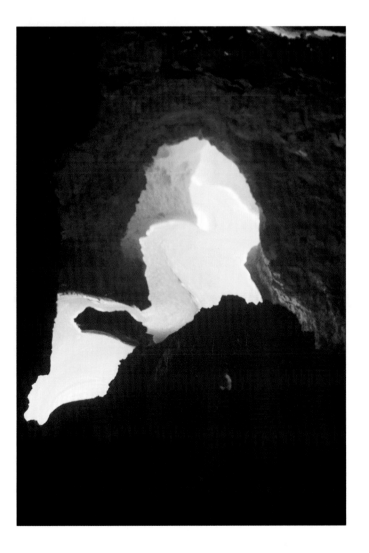

BOTTOM
The river of lava within a mature lava tube melts its way deeper into the flank, sometimes cutting into preexisting flows. The roof is left high and unsupported by the flow. Gases rushing through the cavern are hot enough to melt the surrounding rock, so that a lava tube grows both deeper and wider with time.

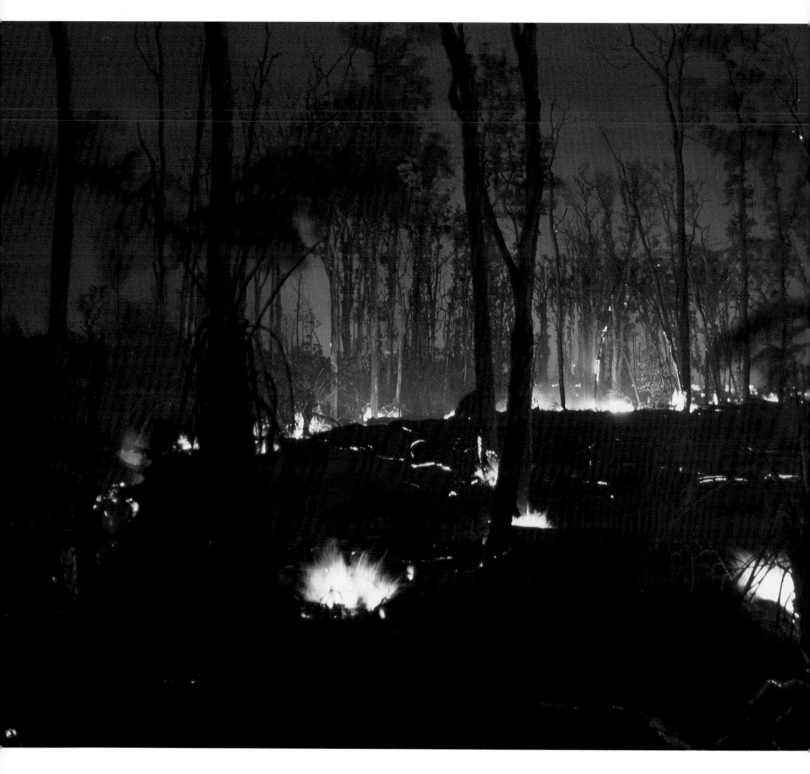

ABOVE
The flood of hot pahoehoe cuts through the
forest like a fiery sword. Trees and vegetation
engulfed by the advancing flow produce
methane gas that burns with a purple flame.

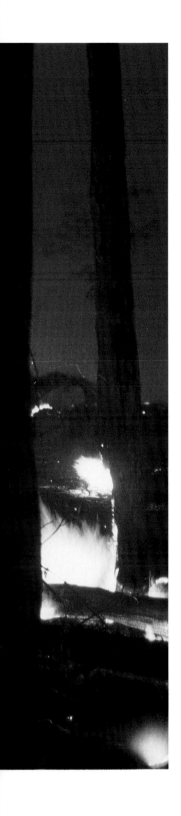

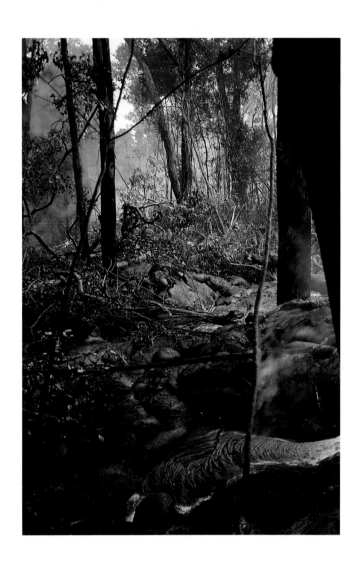

Pahoehoe flows sometimes creep through the forest by forming lobes of lava called toes. Lava toes develop as molten rock oozes from a crack in a flow's thickening rind, slowly expanding as its surface cools to a leathery skin. Some flow fields are built up of thousands upon thousands of lava toes stacked one upon the other.

RIGHT

A'a channels can be pirated by later pahoehoe flows. Pahoehoe breaking through the walls of an a'a channel seems to contradict the rule that a'a flows never change to pahoehoe.

TOP RIGHT

Lava cooling on the surface of a shield volcano assumes one of two basic forms. The earliest flows often cool and form a'a, which are then covered by hotter pahoehoe flows, as seen here, that follow. Pahoehoe cools to a smooth ropy surface.

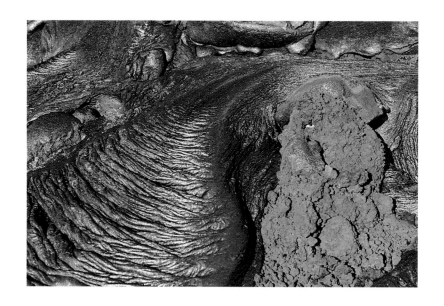

BOTTOM RIGHT

Some lava flows seem to be transitional between pahoehoe and a'a, forming a sharp, brittle surface much like an array of sharp knives randomly arranged.

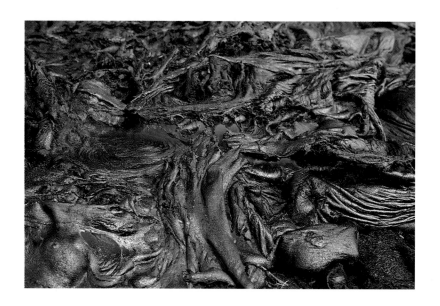

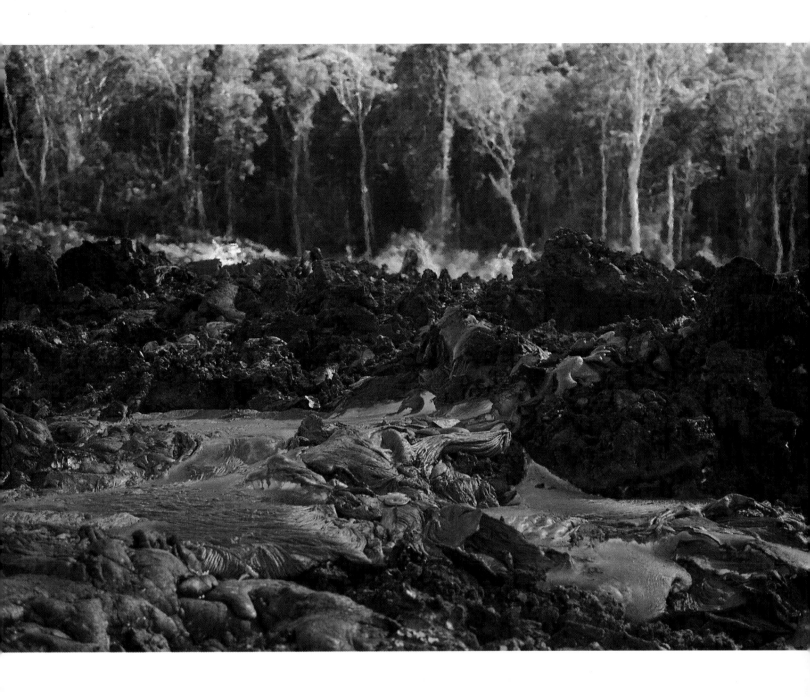

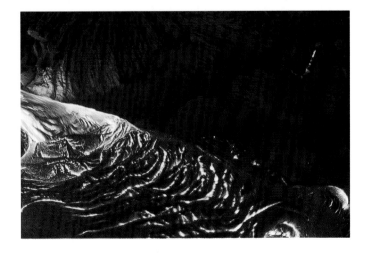

Cooling pahoehoe forms
ropy folds as it comes to rest.
The deep folds are made
incandescent by the heat still
retained within the flow.

RIGHT

When lava first reaches the sea it dangles from the sea cliffs like ribbons of red taffy. Again and again they are broken and carried away by the pounding surf.

RIGHT

At first the meeting of lava and water is calm, as a layer of water vapor insulates the rest of the water from the intense heat of molten rock. This quiet does not last, and as more massive flows follow, the interaction between lava and water can become explosive.

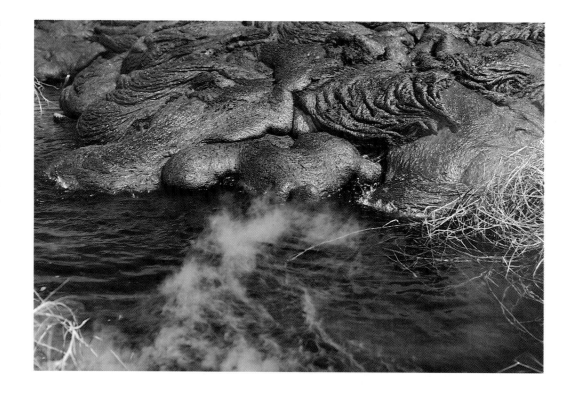

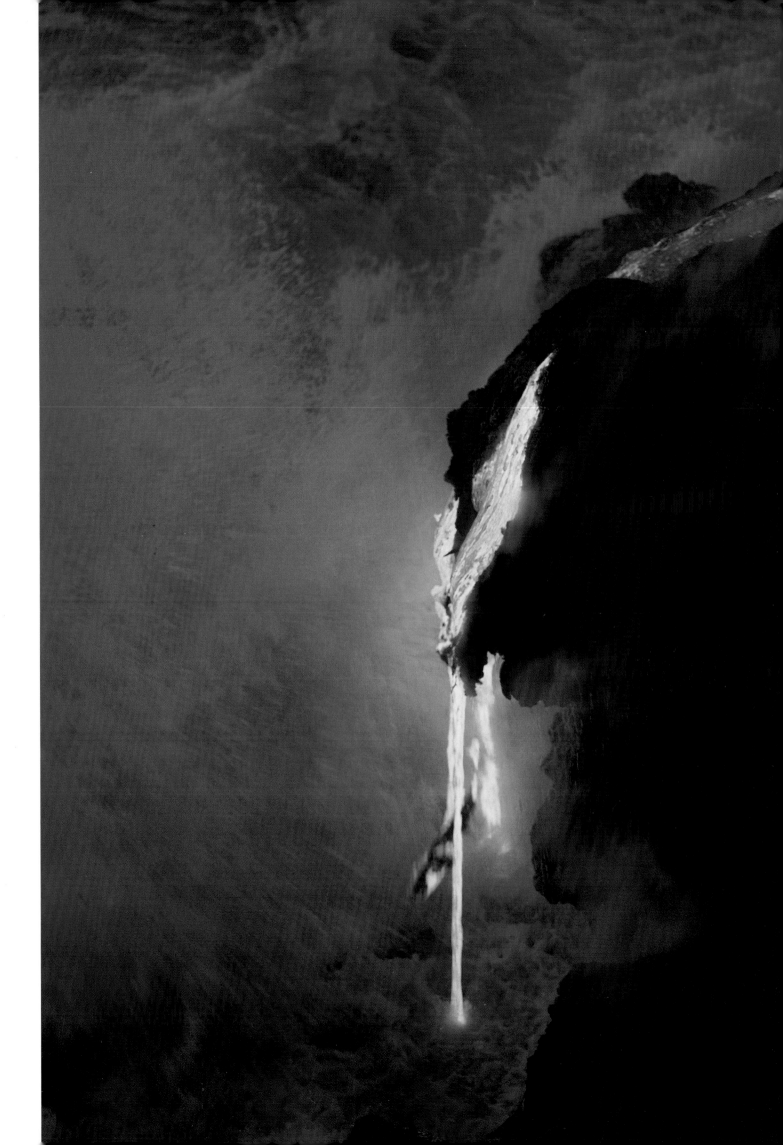

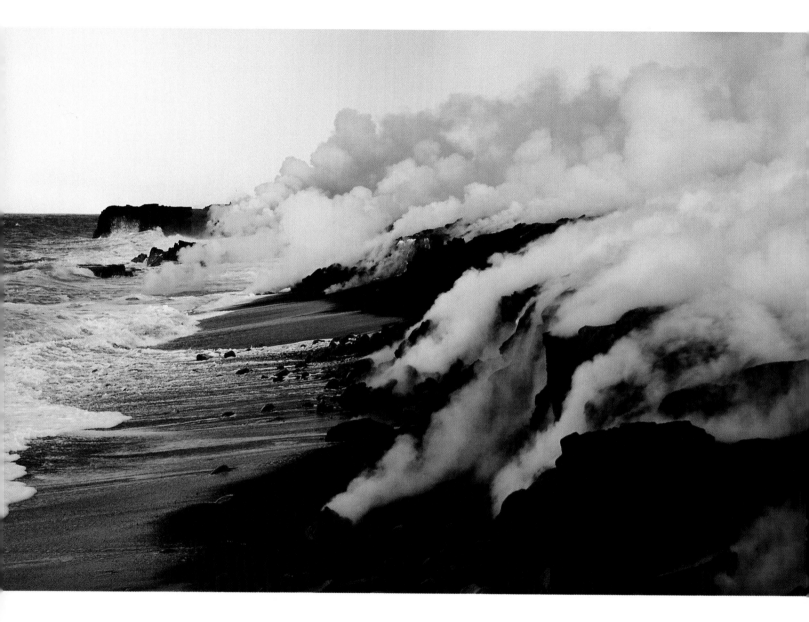

*As lava reaches the sea
faster than the waves can
carry it away, a new
point of land begins to
grow seaward.*

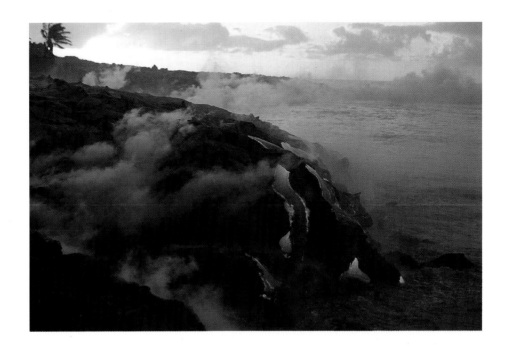

*The first flows enter the
sea as many small streams
spread over a broad front.
A small, white steam
plume rises from
each entry.*

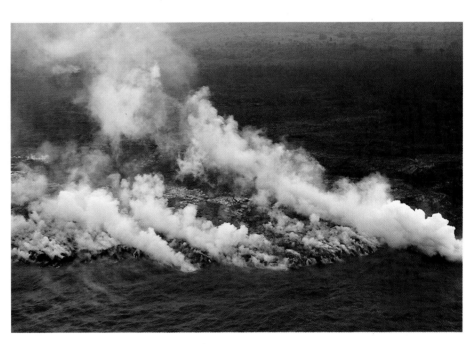

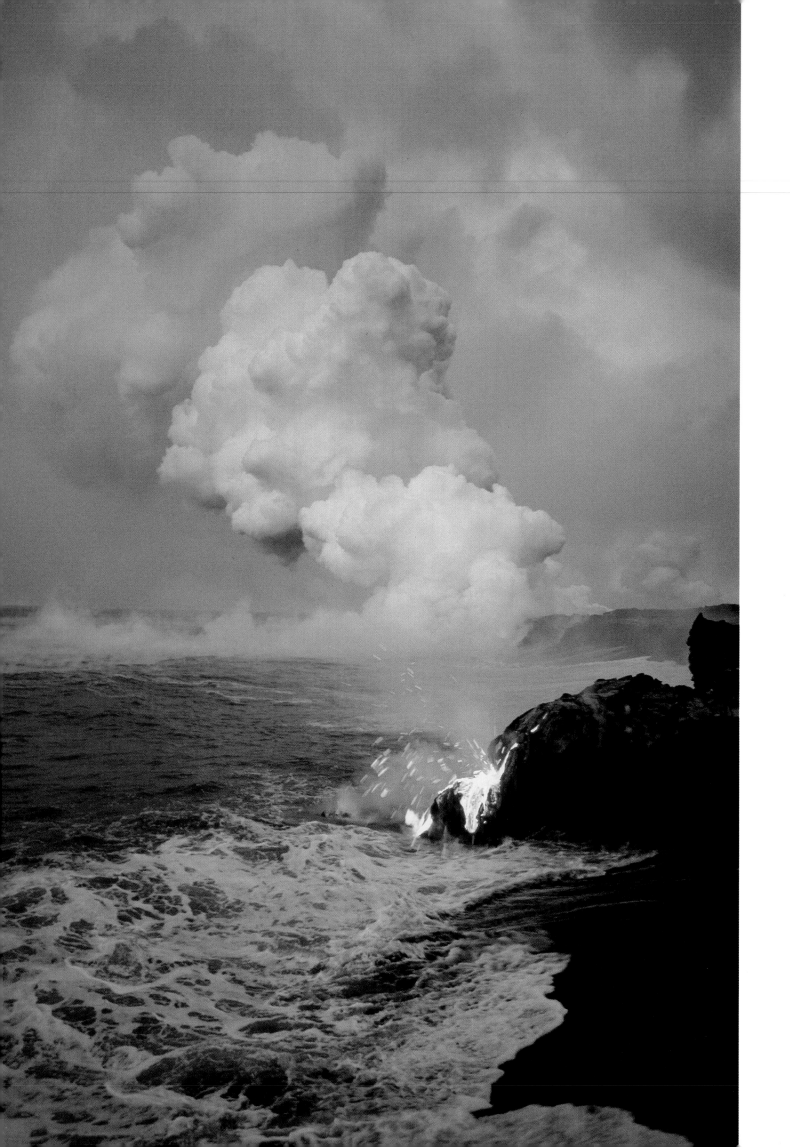

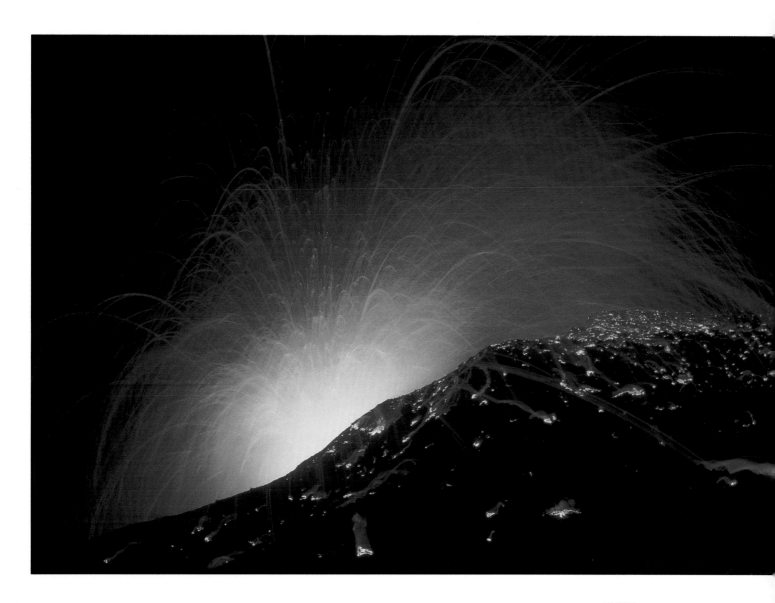

A turbulent plume of hydrochloric acid billows
from the sea where a large lava tube empties
directly into the waves.

In apparent defiance of the
power of the waves, tubes are
built through the surf, and onto
the submarine flanks of the
volcano. Pounding surf can
break through the roof of these
tubes. As cold seawater invades
the incandescent interior of a
broken tube, rock explodes like
fireworks from the surf.

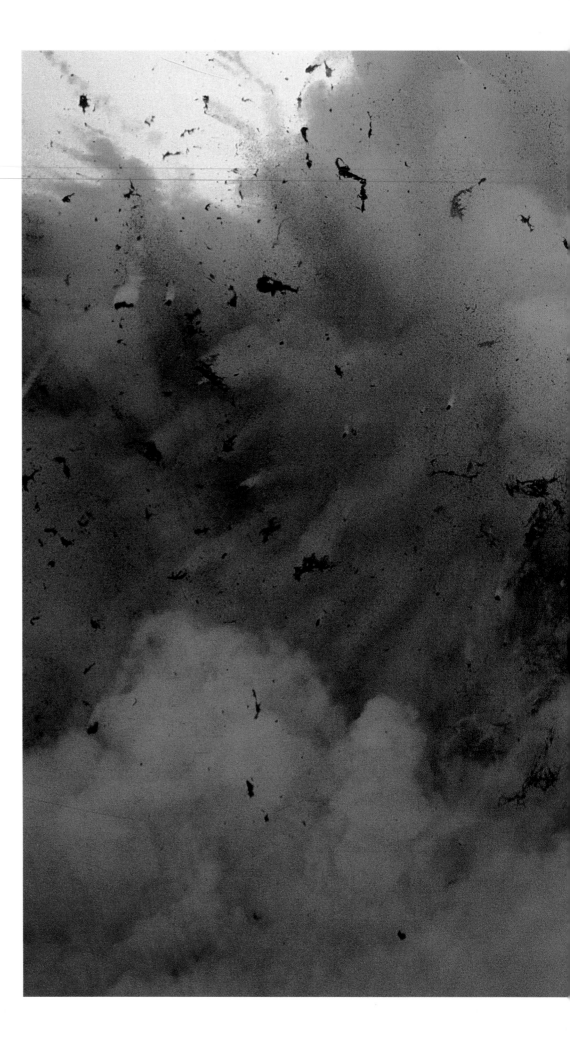

*Slabs of newly formed coast
break off and fall away, leaving
a stream of lava arching from a
severed tube. Steam and ash
explode from the surf as water
invades the submerged portion
of the truncated tube.*

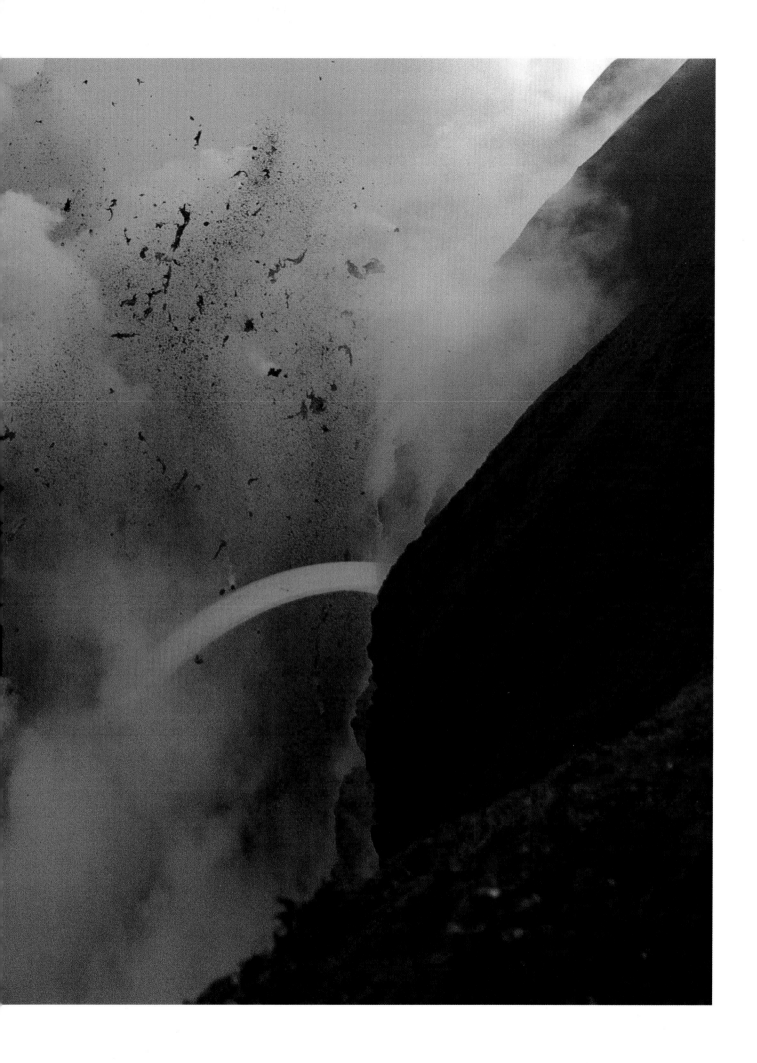

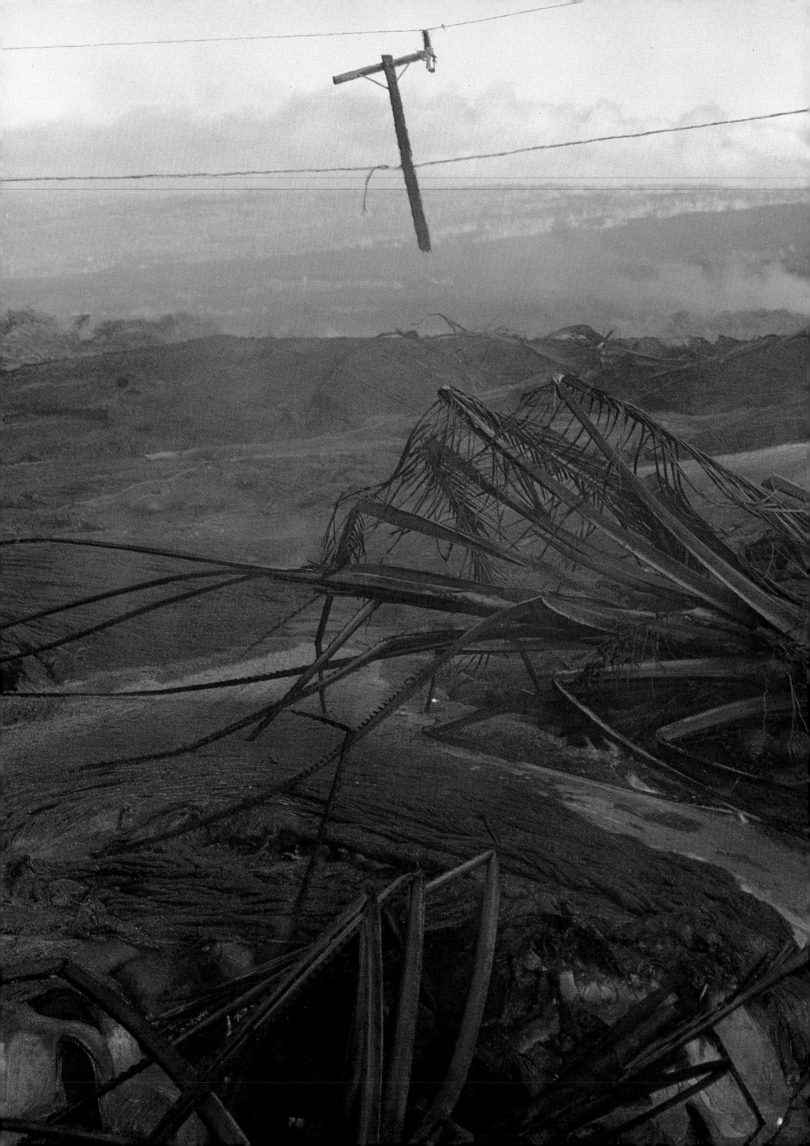

Chapter 7

Living with Volcanoes

Civilization exists
by geological
consent, subject
to change without
notice . . .

— WILL DURANT

Chapter 7

Living with Volcanoes

We are much more aware of the destructiveness of volcanoes than the great benefits that come with the passage of time. The destruction of St. Pierre, the devastating eruption of Mount St. Helens, and the explosion of Krakatau were headline news throughout the world. On stratovolcanoes, the risk is exposure to avalanches of incandescent rock, drowning in hot mud, or burial beneath tons of hot, powdery ash. Those living on shield volcanoes must occasionally accept lava flowing down city streets, burning homes to the ground and encasing everything else in sheets of solid rock. The outpouring of melted rock defies all man's notions of the ownership of the land. But it is really the slower changes that occur as life regenerates upon the land that represent the largest immediate impact volcanoes have on our lives.

On shield volcanoes, the process of recovery begins soon after a sustained eruption ends. Recent flows have cut black corridors of stone through the dense forest, leaving islands of green which the Hawaiians call kipukas. The new landscape is barren and desolate, but soon sun and rain work their subtle magic, and not so many generations of man will pass before the land can support a luxuriant, green forest. Long before that, and only a few days after the lava cools, new life begins to spread outward from the kipukas. Survival does not come easily to these early pioneers, but over time, a thin layer of organic soil is formed. A few species of ferns and trees are among the earliest plants to grow on new lava. Their ability to grow where other plants cannot gives them a competitive edge in a land where every square kilometer is resurfaced every few thousand years. With the arrival of the Polynesians, man began to play a role in the revitalization of the land. Seeing themselves as custodians of the land, the Hawaiian people were able to hasten the return of life to the barren flows, and the cycle of destruction, growth, and renewal was completed.

Over longer spans of time volcanic island chains offer some unique challenges to the life forms that inhabit them. Each island continues to grow as long as the volcanic fires within remain alive, maintaining a delicate balance with the power of the sea. Eventually, new lava will cease to flow. As waves wear away the shore from all directions, the island becomes steadily smaller, finally disappearing back into the ocean from whence it came. Cut off from other lands by thousands of kilometers

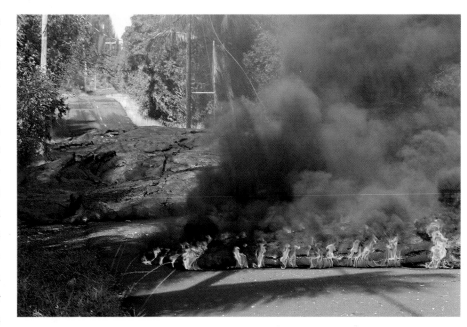

A B O V E

Living on an active volcano, one must occasionally accept lava running down the street. Acrid black smoke rises as asphalt is ignited by the intense heat.

of open ocean, new species arrive approximately once every hundred thousand years. Even for those plants and animals that manage to establish themselves, the challenge continues. Islands of the Hawaiian chain remain above the waves for only about five million years. During this time all life forms must migrate to each new island as it rises and becomes new land. To miss even once threatens extinction. As a result, species have developed that are particularly well-adapted to the demands of living with lava and in winning the race down the island chain upon which their very survival depends.

The process is much the same on stratovolcanoes. Recovery is slower, since the area of destruction is generally vast and no kipukas remain from which life can spread. Water soaks quickly through the porous ash that often covers stratovolcanoes after an eruption ends. In either case, new growth eventually takes hold, and the tear in the thin film of life covering parts of our planet is repaired.

To the burgeoning population of the world, many benefits are derived from volcanoes. The rich and fertile slopes bring forth an abundance of plant and animal life. Many valuable crops flourish on volcanic soil; indeed, some can live nowhere else. Much of the world's most valuable mineral ores—gold, silver, and platinum—for example, are created by volcanic processes. Volcanic lands provide the foundations for entire nations, such as Japan and Indonesia. Volcanic processes provide the atmosphere we breathe and water to fill the oceans of the world. Occasionally there is a price in human terms, and when the time comes, this levy cannot be denied. But on the whole, the benefits far exceed the toll. Truly, the Earth, a blue and white marble floating in space, is a gem among the stars.

RIGHT
For centuries the ancient Hawaiians have built dwellings and temples along the rugged volcanic coast. From time to time they were engulfed in lava, becoming forever a part of this growing land. The efficacy of building with walls of stone is demonstrated here by an ancient Hawaiian temple, called a heiau, that survived while the ground was buried by flows for kilometers in all directions.

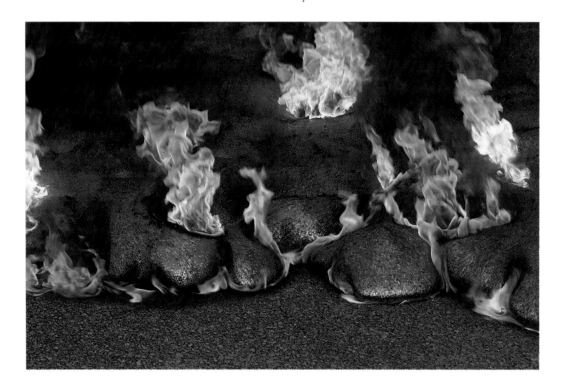

ABOVE
Silky red flames and dense black smoke rise languidly between expanding lava toes as pahoehoe advances slowly along a road.

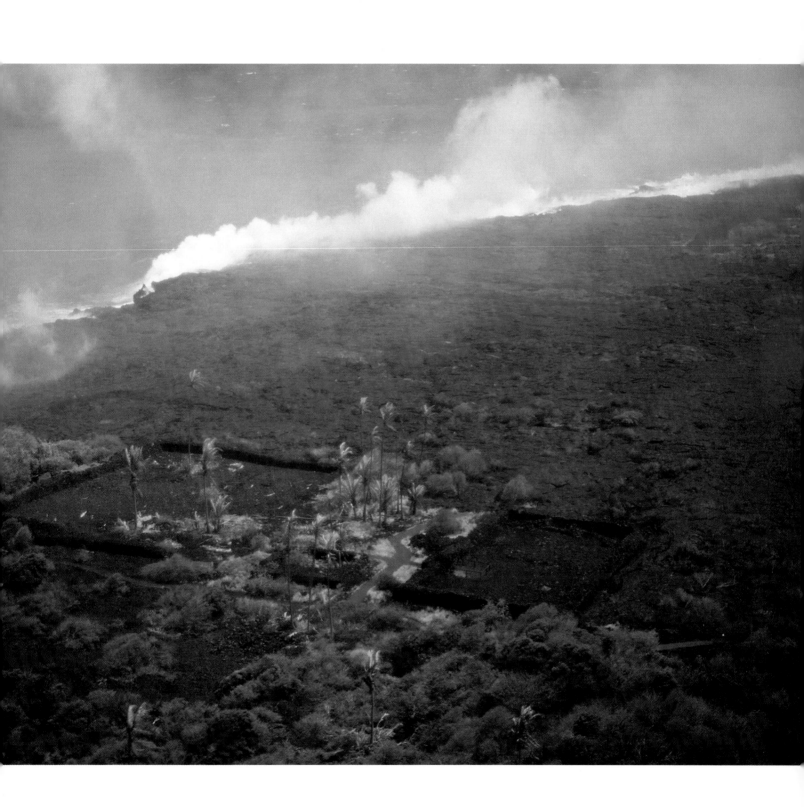

RIGHT
No building is immune to the
destructive force of a volcano.

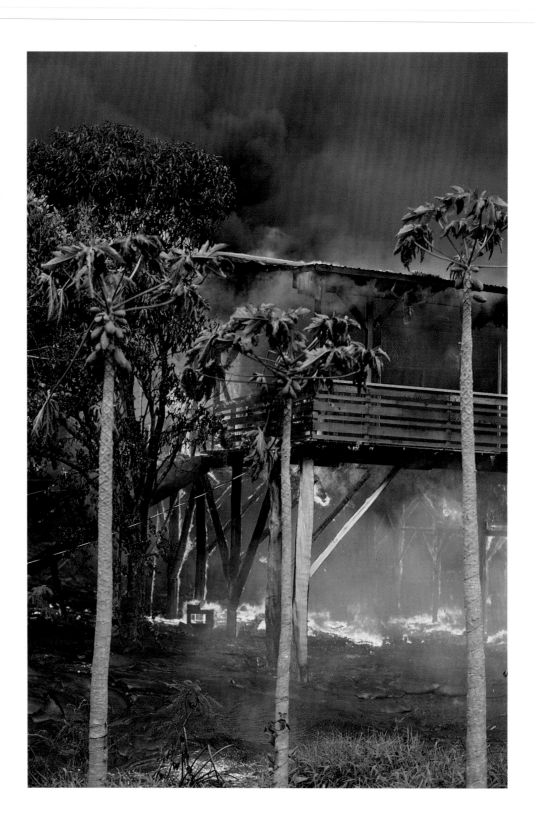

RIGHT
Modern dwellings succumb to
the volcanic forces that shape
the land. Wooden homes burst
into flames from the intense
radiant heat before the flow
from Kilauea Volcano in 1990
reaches their foundations.

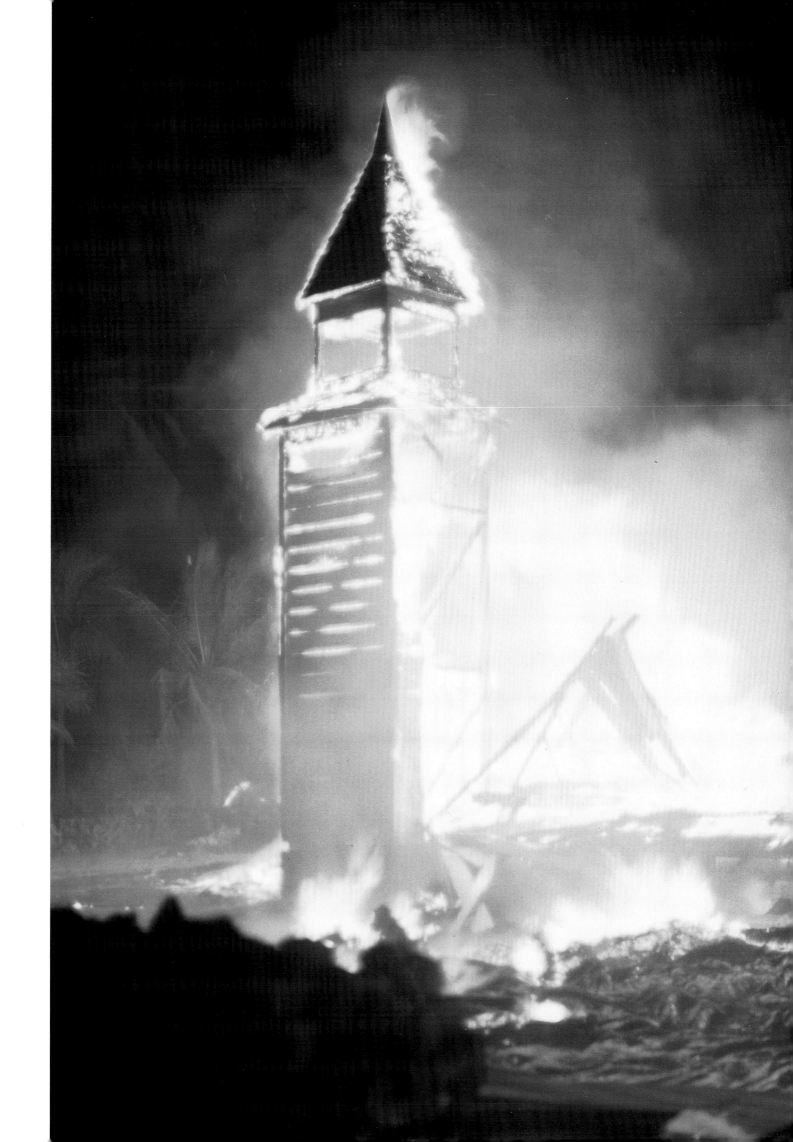

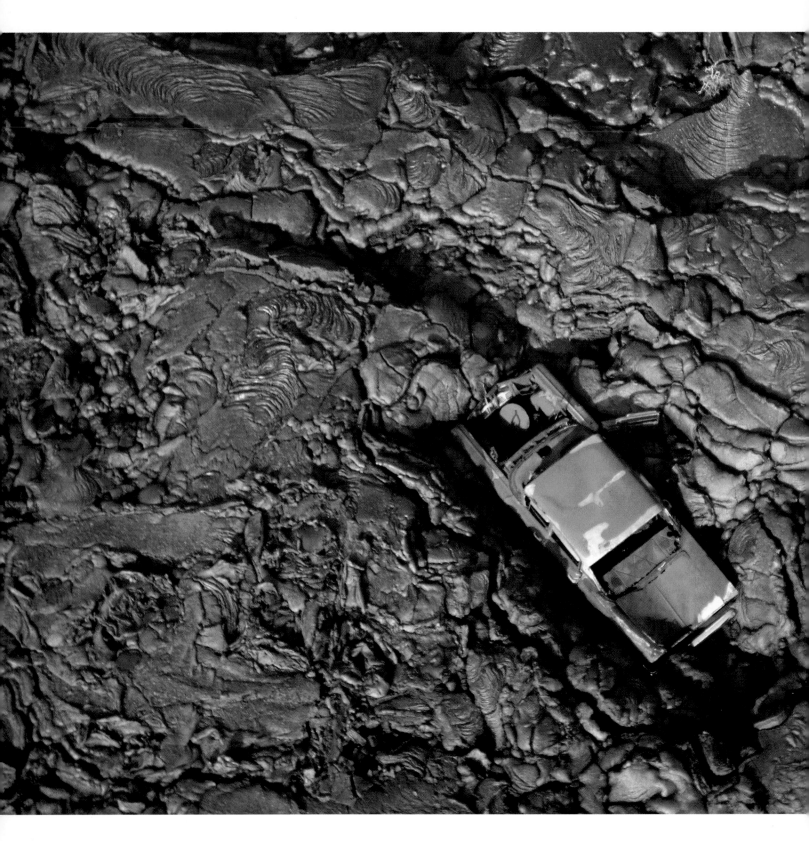

ABOVE
All that does not burn is
frozen into stone as the new
landscape cools.

ABOVE
The artifacts of modern man
are now being added to
the layers that make up
a shield volcano.

LIVING WITH VOLCANOES **123**

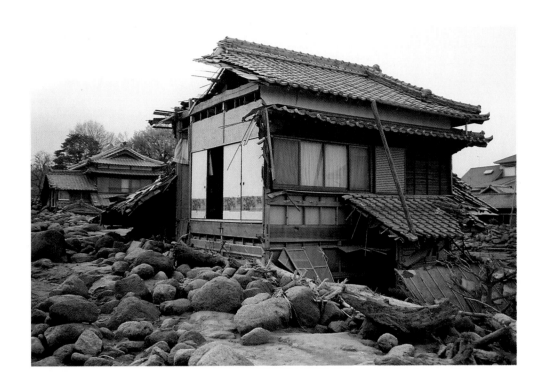

TOP
The works of man were
ground to splinters beneath
the onslaught of boulders and
debris that roared down the
flanks of Unzen Volcano. The
rich, fertile soil formed from
a lahar lures many into the
path of future destruction.
PHOTOGRAPH BY OSAMU OSHIMA.

BOTTOM
Large but very light boulders
of volcanic pumice float high
on the surface of a lahar,
coming to rest in some very
incongruous locations.
PHOTOGRAPH BY OSAMU OSHIMA.

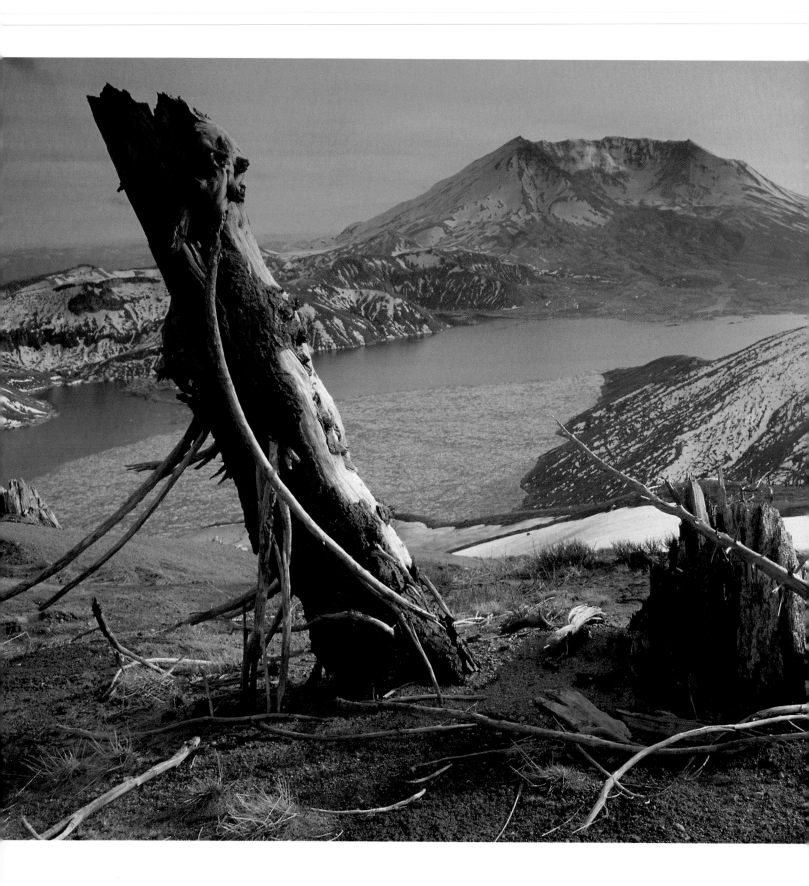

On stratovolcanoes the recovery process takes a little longer, but here too, new life creeps in from the edges. An eruption's barren scar will soon be erased and forgotten as life draws nutrients from the rich, volcanic soil. PHOTOGRAPH BY ROGER WERTH.

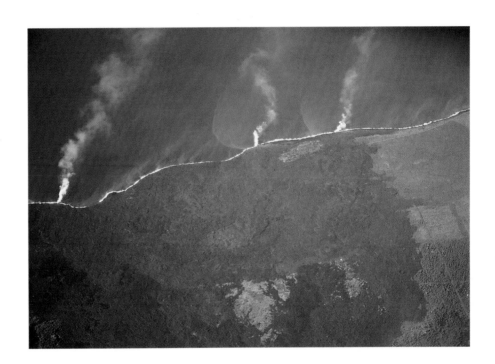

ABOVE

Life and death on an active volcano are in balance. As one part of the volcano is scourged by fiery flows, older flows on another part are weathering to rich, volcanic soil. Eventually the processes of purging and regrowth visit each part of the volcano in a cycle that repeats for hundreds of thousands of years.

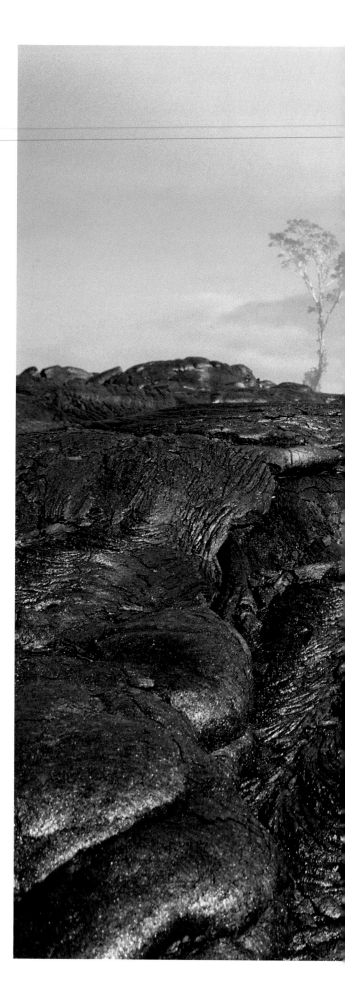

BELOW
Lava flows cover the land in a patchwork of flows
of varying ages; old and young lie side by side.
Ancient vents are eventually engulfed, as
outpourings of molten rock resurface the flanks
of a shield volcano, like Kilauea,
every thousand years or so.

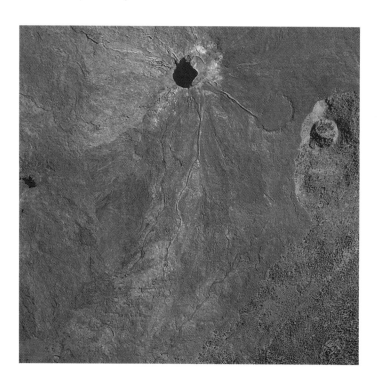

RIGHT
As a massive lava flow begins to cool, green
islands of life known as kipukas remain here
and there, somehow bypassed by the torrents
of melted rock. Life quickly springs forth
from these sanctuaries, eventually recovering
the lifeless, black flows with a new mantle
of deep forest green. The cycle of life
on a volcano is completed.

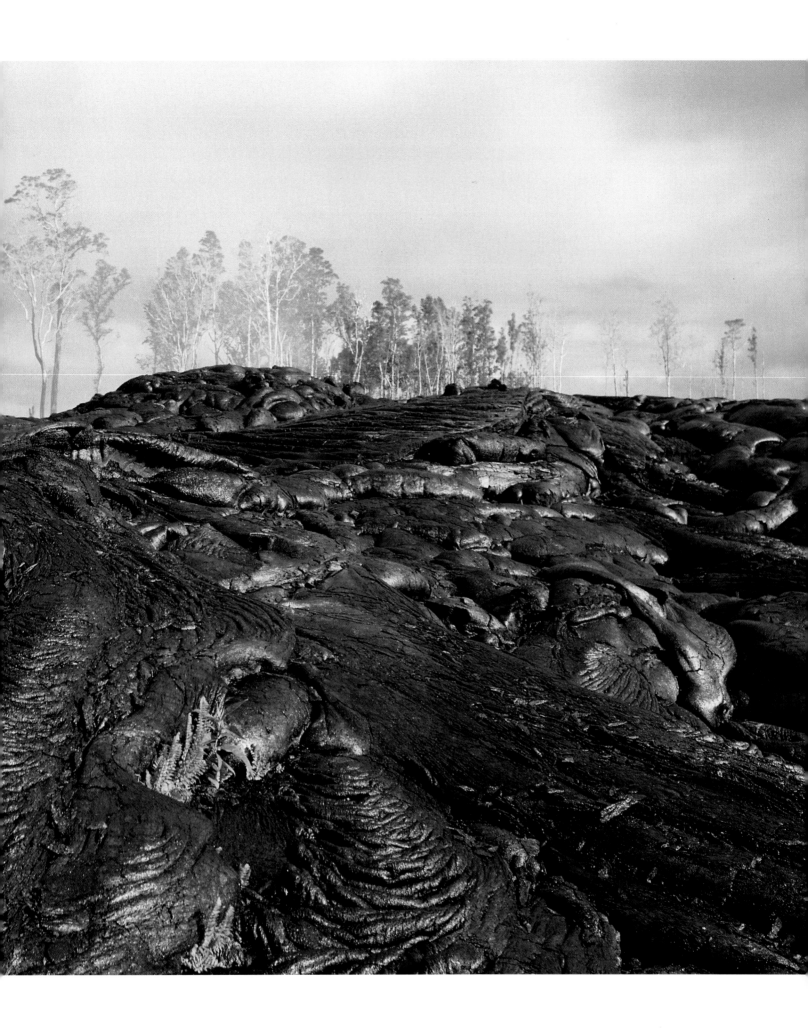

Glossary

a'a A kind of lava with a loose, rubbly surface. Such flows are generally uneven in thickness with steep margins.

andesite A type of lava common to stratovolcanoes having less iron and more lighter minerals than basalt.

ash Fine fragments of lava ranging from dust size to 1 cm formed during explosive eruptions.

asthenosphere That region of the Earth's mantle lying just below the lithosphere. The asthenosphere behaves like a very thick liquid, and slow currents provide the forces that raise mountains and move the continents around.

basalt An iron-rich type of rock formed from solidified lava. Basalt forms the bottoms of the world's oceans and commonly forms shield volcanoes when melted basalt is erupted onto the Earth's surface.

caldera A large, steep-walled depression often located at the summit of a volcano. Both calderas and craters are formed when magma is withdrawn from a shallow magma chamber, leaving its roof unsupported.

cinder Fragments of solidified lava larger than 1 cm.

composite cone *See* stratovolcano.

conduit A crack or tube-shaped passageway by which magma reaches the surface of the Earth.

continent The part of the Earth's surface that stands above the oceans. Continents formed early in Earth's history and contain much older rocks than are found on ocean floors.

crater A steep-walled depression near the summit of an active volcano. A large crater is called a caldera.

crust The thin, outermost layer of the Earth.

curtain of fire A dramatic sheetlike eruption of frothy lava formed as adjacent fountains merge during a fissure eruption.

diapir A somewhat balloon-shaped body of magma rising through denser, deformable rock on its way towards the Earth's surface.

dike *See* intrusion.

earthquake Sometimes violent vibrations of the Earth as energy is released by a crack formed suddenly underground.

eruption column A white, grey, or black column of gas and volcanic ash that forms during explosive volcanic eruptions. Eruption columns can reach tens of kilometers into the atmosphere.

fissure A narrow fracture that forms as magma approaches the Earth's surface, sometimes serving as an eruptive vent.

flow front The advancing margin of a lava flow.

hot spot Places on the Earth where rising mantle currents produce magma that can be erupted onto the Earth's surface. Hot spots beneath moving plates produce lines of aging volcanoes.

intrusion Magma moving through an extending, narrow crack pushing the surrounding rock aside as it advances.

kipuka The Hawaiian word for a remnant of forest bypassed by a lava flow, and left as an island of green after the flows cool.

lahar Mudflows on the slopes of volcanoes that occur when unstable layers of ash and debris become saturated with water. Lahars are common during eruptions of glacier-capped stratovolcanoes.

lava The name for magma after it reaches the surface of the earth.

lava lake A pool of molten rock, sometimes forming a thin, plastic skin of rock which is ripped and torn by currents and the release of volcanic gases from below.

lava tube A hollow passageway through which lava flows. Lava tubes insulate the flow, allowing it to travel for great distances before solidifying.

lithosphere The rigid outer shell of the Earth, about 100 kilometers thick.

magma Molten rock beneath the Earth's surface which includes dissolved gases and suspended crystals.

magma chamber A magma reservoir beneath the surface of the Earth.

Suggested Reading

mantle The 2,900-kilometer-thick layer of rock located between the Earth's core and the base of the crust.

meteor Celestial bodies ranging in size from a speck of dust to asteroids weighing thousands of kilograms. Meteors appear as shooting stars when they enter Earth's atmosphere. Meteors large enough to penetrate a planet's atmosphere leave craters on its surface.

nuées ardentes An avalanche of incandescent ash and gas moving rapidly down the flanks of a volcano and destroying everything in its path.

pahoehoe A solidified lava flow with a smooth, liquidlike surface.

pillow lava A pillow-shaped structure formed during undersea eruptions as lava extruded into cold sea water quickly develops a thick rind that inhibits its further expansion.

plate tectonics The theory that Earth's surface is made up of a few large plates nearly 100 kilometers thick. The relative motion of these plates and their interaction determine the location and type of volcanic activity.

pumice A foamlike, expanded form of solidified lava derived from thick, gas-rich magma. Pumice, light enough to float on water, is most generally associated with stratovolcanoes.

rift zone Linear zones of fracture on shield volcanoes along which eruptions are concentrated. Long, tensional cracks are common along rift zones.

shield volcano A low, flat volcano named for its resemblance to a shield. Shield volcanoes are found on many planets other than Earth, and owe their shape to the fluid lava that can flow large distances to form gentle slopes.

skylight A collapse of the roof of a lava tube that permits a view of the river of lava flowing within.

stratovolcano A steep-sided volcano weakly constructed of alternating layers of lava and ash.

tsunami The Japanese word for a seismic sea wave.

vent An opening at the Earth's surface through which lava, ash, and gases are ejected during an eruption.

Decker, Robert, and Decker, Barbara.
Mountains of Fire — The Nature of Volcanoes.
Cambridge, UK; Cambridge University Press 1991.

Dvorak, J. J., Johnson, C. E., and Tilling, R. I.
"Dynamics of Kilauea Volcano."
Scientific American 267, no. 2 (August 1992): 46-53.

Editors of Time-Life Books.
Volcano.
Alexandria, VA; Time-Life Books 1982.

Grove, Noel.
"Volcanoes — Crucibles of Creation."
National Geographic (December 1992): 5-41.

Krafft, Maurice, and Krafft, Katia.
Volcanoes: Earth's Awakening.
Maplewood, NJ; Hammond 1980.

Weisel, Dorian, and Heliker, Christina.
Kilauea — The Newest Land on Earth.
Honolulu, HI; Bishop Museum Press 1990.

Weisel, Dorian, and Stapleton, Frankie.
Aloha O Kalapana.
Honolulu, HI; Bishop Museum Press 1992.

Index